Flora Symbolica

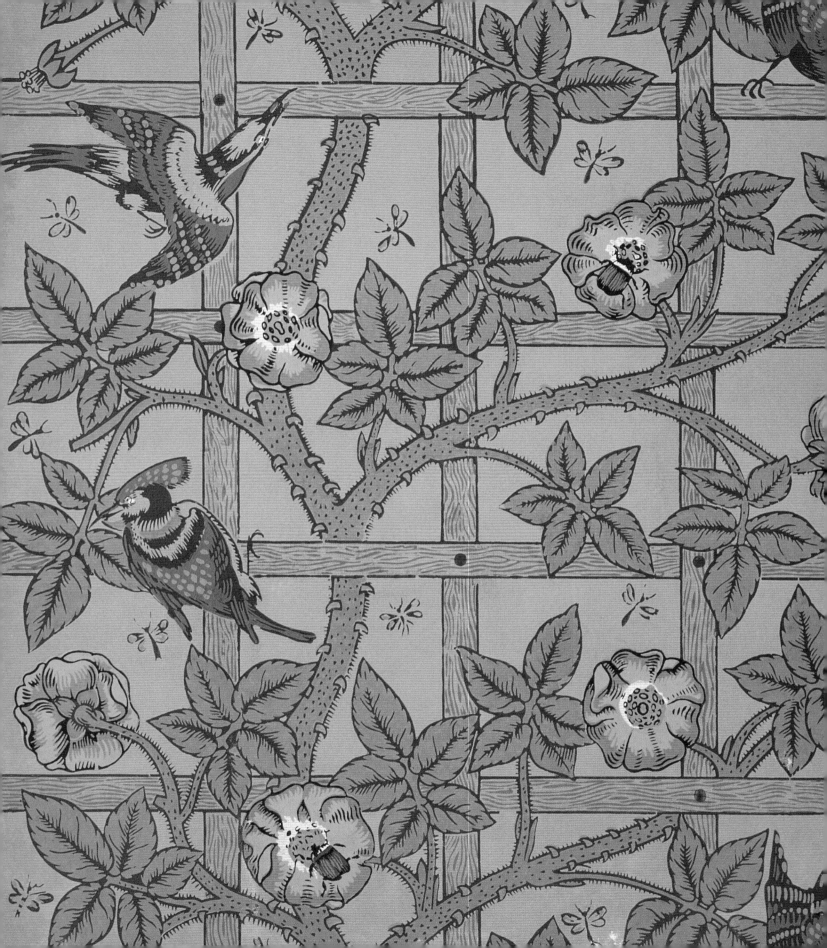

Debra N. Mancoff

Flora Symbolica

Flowers in Pre-Raphaelite Art

Prestel

Munich · Berlin · London · New York

Acknowledgments

© for text by Debra N. Mancoff
© for design and layout by Prestel Verlag, Munich · Berlin · London · New York, 2003
© for illustrations see Picture Credits, p. 88–91

The right of Debra N. Mancoff to be identified as author of this work has been asserted in accordance with the Copyright, Designs and Patents Act 1988.

Front jacket: Dante Gabriel Rossetti, *La Ghirlandata* (1871–74), see p. 42
Back jacket: Kate Hayllar, *Sunflowers and Hollyhocks* (1889), see p. 72
Spine: J. W. Waterhouse, *The Soul of the Rose* (1908) detail, see p. 50

Prestel-Verlag
Königinstr. 9
D-80539 Munich
Tel.: (89) 38-17-09-0
Fax.: (89) 38-17-09-35
www.prestel.de

Prestel Publishing Ltd.
4 Bloomsbury Place
London
WC1A 2QA
Tel.: (020) 7323 5004
Fax.: (020) 7636 8004

Prestel Publishing
175 Fifth Avenue, Suite 402
New York
NY 10010
Tel.: (212) 995 2720
Fax.: (212) 995 2733
www.prestel.com

Library of Congress Control Number: 2002116865

Prestel books are available worldwide. Please contact your nearest book-seller or any of the above addresses for information concerning your local distributor.

Editorial direction: Philippa Hurd
Design and typesetting: Ulrike Schmidt, Munich
Origination: Trevicolor, Treviso, Italy
Printing and binding: Graspo, Zlín
Printed in the Czech Republic on acid-free paper

ISBN 3-7913-2851-4

This book allowed me to engage in a topic that has long intrigued me, and I would like to express my gratitude to all the people who helped bring it into being. First and foremost I would like to thank my editor, Philippa Hurd, for her encouragement, enthusiasm, and excellent advice. I also thank Ulrike Schmidt for a design that reflects the book's spirit. For sharing their insights on floral iconography, flowers, and Victorian culture I want to acknowledge Peter Kort Zegers of the Art Institute of Chicago, Professor Thomas L. Sloan of the School of the Art Institute of Chicago, Professor Linda K. Hughes of Texas Christian University, my cousin and fellow author Marcia Reiss, and my father Philip Mancoff. For their unflagging energy and creativity I thank my research assistants Theresa M. Corsentino and Maya Sohonie. A special debt of gratitude goes to John Troiani for the many times he helped me out with his technical expertise. I thank the Newberry Library of Chicago for supporting my research as a Scholar in Residence and Marcy Neth and Rosalyn Gray of the Flaxman Library of the School of the Art Institute of Chicago, Josh Eisenberg of the Ryerson Library of the Art Institute of Chicago, and Helen Dobson of the Victoria and Albert Museum, London, for reference assistance. Thanks as well to Shay DeGrandis, Justin Brown, Erin Hanas, and Amanda Freymann for being there for me at the right time. I appreciate the encouragement of my friends Ann M. Brizzolara, Caroline Bugler, Donald L. Hoffman, and Susan Regele, as well as the patience and loving support of my father and my mother Elinor R. Mancoff. And I would like to dedicate this book to my dear friend Paul B. Jaskot, who sees things differently from me, but makes room in his heart for a romantic point of view.

Debra N. Mancoff
Chicago, February 2002

Contents

Introduction

The influential art critic Walter Pater believed that the appreciation of Pre-Raphaelite art depended upon the viewer's fluency in an esoteric language of symbols. As an example, he noted that Dante Gabriel Rossetti often ornamented his canvases with flowers. Pater lamented that many ("the ignorant") saw the flowers as nothing more than an "intrusive enigma." But, he countered: "To the initiated this flower speaks parables." It is true that Rossetti drew upon a diverse–and sometimes eccentric–range of sources to endow his art with meaning. William Michael Rossetti observed that in his brother's painting the image was inseparable from the idea it communicated, and that there was very little in Rossetti's art that could be regarded as straightforward reality, "unimbued by some inventive or ideal meaning." But Rossetti was not alone in his desire to inscribe his imagery with iconic expression. The practice of rendering meaning into every object on his canvas–from an elaborate garden observed from nature to the humblest flower plucked to paint in the studio–could be traced to his youthful ambitions in art that led to the founding of the Pre-Raphaelite Brotherhood.

In 1848, seven young men–Rossetti, his brother William, John Everett Millais, William Holman Hunt, Frederick Stephens, Thomas Woolner, and James Collinson–launched a romantic revolution in the arts. They shared a disdain for the prevailing standards of contemporary art, which they believed had been tainted by centuries of artifice and false sentiment. As an alternative they pledged to revive the aesthetic simplicity and the moral sincerity that characterized the spirit of European art prior to the time of Raphael. For inspiration, they drew up a list of "Immortals" ranging from Jesus Christ and Shakespeare to Elizabeth Barrett Browning and Edgar Allan Poe. Four principles defined their aims: "1. To have genuine ideas to express; 2. to study Nature attentively, so as to know

how to express them; 3. to sympathize with what is direct and serious and heartfelt in previous art...and; 4. most indispensable of all, to produce thoroughly good pictures and statues." In honor of the art they most admired, they called themselves the Pre-Raphaelite Brotherhood.

The alliance of nature with the expression of genuine ideas in art links the aims of the original Brotherhood with the writings of John Ruskin. In the second volume of his magnum opus *Modern Painters* (1843–60), the art critic instructed the artist to follow nature, "rejecting nothing, selecting nothing, and scorning nothing." Truth, Ruskin asserted, was to be found in nature, and the Pre-Raphaelite Brothers affirmed this belief through their faithful rendering of the natural world. Ruskin, in turn, became their most articulate champion, defending their ambitions and explaining their objectives in letters to the *Times* of London in 1851.

Never more than a loose association of like-minded artists and writers, the original Brotherhood was short-lived, and by 1853 it had disbanded. But in the course of five short years, the Brothers attracted both harsh and celebratory critics, a supportive circle of patrons, and a broad range of talented men and women who encouraged their efforts, adopted their aesthetic, and advanced their cause. Among the latter were William Morris and Edward Burne-Jones. Along with Rossetti, they formed a second generation of Pre-Raphaelites, and their work, in both the fine and decorative arts, added romance and imagination to the original aims of genuine sentiment and fidelity to nature.

Their promotion of fine craftsmanship laid the foundation for the Arts and Crafts Movement, and the beauty of their paintings–ranging from Rossetti's sensuous "Venetian pictures" to Burne-Jones's ethereal visions of legend and lore–defined the idealized canon of the Aesthetic Movement as

advanced in the writings of Pater and Oscar Wilde. In their challenge to artistic conventions, the Pre-Raphaelites pioneered a broader individuality in British painting, and their influence endured through the early years of the twentieth century.

The adoption of Ruskin's dictum "Truth to Nature" set the Pre-Raphaelites apart from conventional art, but at the same time it drew them into one of the most popular trends in Victorian culture. From the early years of the nineteenth century, botanical science and flower cultivation gained popular status in Britain. Amateur botany became a common avocation, as did gardening, flower arranging, and crafts that involved dried branches and blooms. This widening audience for floral culture also resulted in the increased publication of botanical books. Straightforward plant histories, such as Henry Phillips's *Flora Historica* (1824), were popular early in the century, but within decades they were superseded by books that combined botanical information and tips on cultivation with snippets of legend and lore, such as Anna Pratt's *Flowers and Their Associations* (1840) and Mrs. Loudon's *The Ladies' Flower Garden of Ornamental Annuals* (1849). After mid-century, the floral lexicon, an alphabetical list of flowers and their meanings, became a common feature of such volumes. Based on a French model, first published in Charlotte La Tour's *Le Langage des fleurs* (1819), the floral lexicon became the foundation of "florigraphy," flower writing that encoded messages through the colors, positions, and combinations of blooms.

Some books, such as Jane Giraud's *The Flowers of Shakespeare* (1850) and William Elder's *Burns's Bouquets* (1875), concentrated on the floral iconography of a single source, but far more common—and certainly more popular—was the compendium, such as John Henry Ingram's *Flora Symbolica* (1869), which combined a cultural "history" of traditions and rituals, with separate entries on individual flowers, and a double lexicon of both flowers and their meanings. Ingram acknowledged his reliance on other writers, such as Mrs. Loudon and Eliza Cook, but he urged his readers to observe nature and trust their own intuition, explaining "some flowers, indeed, almost bear written upon their upturned faces the thoughts of which they are living representatives," such as the "childlike Daisy" or the "glowing Rose." He admitted that the "science" of florigraphy demanded "but little study," and he assured his readers that flowers speak "a language more powerful, and far more expressive than that of the tongue."

While it is not possible to cite a specific floral lexicon used by the Pre-Raphaelites, their literary sources are the same as those quoted in the flower books: the traditional canon of literature, including the Bible, Geoffrey Chaucer, and William Shakespeare; the Romantic poets, including John Keats, Percy Bysshe Shelley, and William Wordsworth; and contemporary writers such as Alfred Tennyson, Thomas Hood, and Elizabeth Barrett Browning. They shared the same passion for history and legend and, like the authors of the floral books, recovered old texts and gave them new vitality. Their adherence to the credo "Truth to Nature" inspired them to study the flowers they painted with the analytical eye of a botanist. The paintings the original Brotherhood regarded as exemplary—those of the early Italian and the Flemish Renaissance—employed a complex code of disguised symbolism, in which everyday objects, rendered as seen in nature, disguised mystic meanings, and, through this, the Pre-Raphaelite artists added a poetic dimension to their floral expression that transcended the popular lexicon. While the language of flowers may have provided a popular departure point for their symbolic expression, they cloaked their floral iconography in suggestive veils of meaning drawn from their own poetry, their favorite esoteric sources,

and the incidents of their own lives, as can be seen in a closer look at the floral themes in the repertoire of Pre-Raphaelite art.

As a cultural metaphor in the Victorian era, garden walls enclosed more than just blooming flower beds and cultivated climbing vines. The secure confines of the garden defined a safe enclave for personal reflection and intimate relations. With its natural beauty, arranged by design and tended with patient skill, the garden provided a separate sphere untouched by worldly ways. For artists outside the Pre-Raphaelite circle the garden served as a hideaway for a sweethearts' tryst or as a portrait setting to present Queen Victoria as a modern Madonna. But Pre-Raphaelite associates such as William Dyce and Charles Allston Collins, followed Ruskin's dictum "Truth to Nature," and their more didactic approach led them to look for lessons in the natural world and to reflect upon issues of art and spirituality within garden walls (see pp. 10–17).

The poignant tragedy of Ophelia touched Victorian audiences, and her rejection by Hamlet, the loss of her father, and her descent into madness and death were received with heartfelt sympathy. After 1852, when Millais's *Ophelia* debuted at the Royal Academy, the image of the play's pitiable heroine merged with Pre-Raphaelite sentiment and a floral iconography that defined the virtues of youthful femininity. From the medieval era onward, spring flowers, such as the crocus, the primrose, and the lilac, and wild flowers, such as the violet, the pansy, and the daisy, were identified with modesty and first love. Compared to the rich colors and fragrances of more sumptuous summer blooms, the pale tints and delicate contours of these flowers of innocence evoked the first flush of womanly beauty and the precious but precarious stage of life when a girl passes into womanhood (see pp. 18–29).

Whether used as a symbol of the Virgin Mary or presented as an emblem of chaste girlhood, Victorian artists and poets celebrated the "Annunciation Lily" as the purest flower (see pp. 30–39). Floral lexicons assign the *Lilium candidum* the attribute of majesty, a tradition traced back to the classical deity Hera, the Queen of Olympus. Once as she slept, her husband Zeus placed his illegitimate son Hercules at her breast to nurse, but the hearty infant fed so eagerly, he startled her. Drops of milk scattered across the heavens, creating the Milky Way, while those that fell to earth grew into lilies. The Christian era appropriated the lily as Mary's emblem, signifying her majesty in the height of the flower and her chastity in the whiteness of its petals; in the Victorian era Rossetti adopted the Renaissance iconography of the triple-blossomed lily as a symbol of Mary's devotion and sacrifice. As an attribute of love, the lily represented an inviolate purity that, in the words of Elizabeth Barrett Browning, was "prepared to touch/The whitest thought...of dreamer turned to lover."

Praised in art and poetry for its unparalleled beauty the rose reigned as the Victorian queen of the flowers (see pp. 40–51). Christian tradition compared Mary to a rose without a thorn, and her stature among women was likened to that of the rose in a garden, superior to all other flowers. Medieval romance took the rose as the emblem of love. With its beautiful blossom and delightful scent, it stirred the senses. Shakespeare's Juliet, reflecting on her heart's desire, recognized "That which we call a rose/By any other name would smell as sweet," and the poet Robert Herrick urged youth to "Gather ye rosebuds while ye may," linking the brief life of the blossom to the sometimes fleeting nature of affection. As a floral emblem in the Victorian era, the rose took on many meanings, differentiated by variety and color, and Pre-Raphaelite painters added to the lexicon, Rossetti presenting it as a symbol of physical beauty, Burne-

Jones as the heart's desire, and John William Waterhouse as a trigger for sweet recollections.

When William Blake poignantly reflected that "The modest rose puts forth a thorn," he warned that danger could lurk behind a flower's charm. With thorns that tear skin, a rose protects its fragile and short-lived bloom, but the beautiful flower and its heady fragrance entice the admirer to risk the thorns and pick the rose. Other flowers hid malevolence behind their beauty; they were fatal bouquets endowed with the darker forces of nature (see pp. 52–63). In the later nineteenth century beauty and danger converged into an irresistible combination, personified in the *femme fatale*. This transgressive woman exploited her physical allure to satisfy an abnormal appetite for power, material wealth, or carnal gratification. These treacherous beauties appealed to Pre-Raphaelite artists who used roses as signs of sensual desire, or white water lilies that masked foul intentions beneath innocence. Like the narcotic poppy, whose comforting sleep can lead to death, these flowers promised pleasure, but delivered anguish and pain.

On occasion in flower lore, contemporary meanings obscure the original associations. Long before the common sunflower was introduced to Spain from its native environment in the Americas, European naturalists had observed that the petals of the heliotrope followed the diurnal course of the sun, as if worshipping its warming rays. In the sixteenth century the *Helianthus annus*—first called the *Solas indianus*—became known throughout Europe. With its radiant petals that mirrored the image of the sun, it usurped the heliotrope's lore, symbolizing every form of devotion: to a lover, to a parent, to a sovereign, and to the divine. By the early nineteenth century, many gardeners dismissed the sunflower as too common—and even too vulgar—for cultivation.

But in the Victorian era, the sunflower shed its humble status, as well as its iconic meaning. Morris and Burne-Jones admired its stature and simplicity—an ornament worthy of heraldry—and gave the sunflower a romantic medieval heritage. They also explored its potential as a natural element in design, but as the emblem of the Aesthetic Movement—and the personal ensign of its outspoken advocate Oscar Wilde—the sunflower became the fashionable flower, transplanted from the back corner of the garden to the center of the stylish drawing room (see pp. 64–75).

Along with the floral lexicon, Victorian poets added to the language of flowers by incarnating human traits in individual blooms, especially in matters of love. In *Flowers* (1827), Thomas Hood declared the violet a "nun" and the pea a "wanton witch," preferring to "plight with the dainty rose, /For fairest of all is she." In Elizabeth Barrett Browning's *A Flower in a Letter* (1844), she assigned affectionate virtues to popular flowers and mused, "Young maids may wonder if the flowers/Or meanings be the sweeter." But the most creative and innovative use of the floral attribute may be seen in the portraits male Pre-Raphaelite artists painted of the women they loved. Rossetti and Burne-Jones, as well as George Frederick Watts who sympathized with their endeavors, combined conventional meanings with deeply personal messages in their tributes to wives and lovers, models and muses. Each created unique icons for the women who touched their lives. Hiding behind the superficial meanings, intelligible to an audience schooled in the language of flowers, were the private thoughts and intimate desires of the artist to be shared only with the elite and enlightened viewer. These portraits harbor secrets, and, as Pater observed, it is when the Pre-Raphaelites say it with flowers that their paintings speak parables, but only to the initiated (see pp. 76–87).

Queen Victoria with Prince Arthur 1850

Franz Xaver Winterhalter (1805–73)
The Royal Collection, London

The idea of a terrestrial paradise—a verdant realm of sanctity and serenity—has a venerable heritage in western tradition. According to Genesis all earthly life was cradled in a divinely created garden. Although cast out, humanity yearned to recover their lost Eden, and the protected garden endured as a symbol of sacred and secular desire. In the richly evocative Song of Solomon the bridegroom praises his bride as "a garden locked" (4:12), containing within all the rare perfumes and choicest fruits of pleasure as well as the mystery of the "well of living waters" (4:15). The medieval cloister—a gated enclosure with walkways surrounding a well-tended garden—gave material form to this metaphor of divine providence and protection, and it served as a physical counterpart to the symbolic *hortus conclusus*, the walled garden that represented the chaste nature of the Virgin Mary. By the nineteenth century, the enclosed garden had become the perfect setting to honor maternity, wherein the bond of loving mother and trusting child recaptured the grace of innocence.

The German-born painter Franz Xaver Winterhalter drew upon this tradition for a portrait of Queen Victoria and her seventh child, Prince Arthur. Winterhalter was renowned throughout Europe for his dignified likenesses of his royal subjects whose power was defined by the symbols of state. But here, the painter celebrates Victoria as a model of womanly compassion in her devotion to her infant son. With subtle reference—the rose sprigs on Victoria's dress, the enclosing branches that surround her, and the oblong composition that recalls a Renaissance *tondo*—Winterhalter envisions her as a contemporary Madonna and Child in a garden. Providence protects her in this serene setting, both as a mother and as the monarch of the nation.

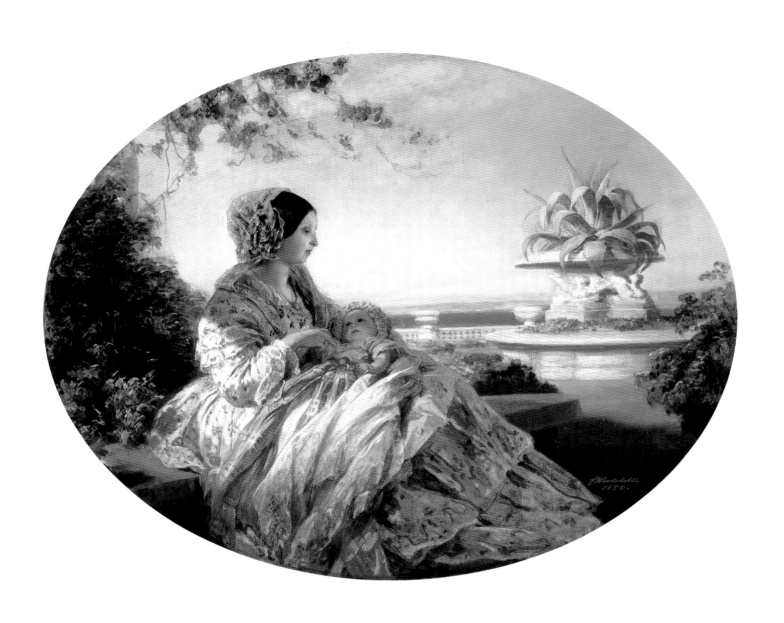

"A garden locked is my sister, my bride."

Song of Solomon (4:12)

Convent Thoughts 1851

Charles Allston Collins (1828–73)
Ashmolean Museum, Oxford

The pious subject of *Convent Thoughts*–a young novice contemplating a passionflower–led critics to assume that Charles Allston Collins was a member of the Pre-Raphaelite Brotherhood. Millais had, in fact, nominated Collins, and although he was not elected, he remained sympathetic to the sincerity of their artistic intentions. In a letter to the *Times* John Ruskin praised Collins's fidelity to natural detail, challenging those who accused the Pre-Raphaelites of eccentricity at the expense of truth to study Collins's brilliant botanical observations. Through careful rendering, Collins gave his painting meaning, and the message of *Convent Thoughts* is expressed in the language of flowers.

Alone in the cloister garden–a true *hortus conclusus*–the novice's attention has strayed from the missal in her hand to the natural beauty that surrounds her. Nature proves to be a telling guide for her meditation. To her right are roses and tall lilies, traditional emblems of the Virgin Mary. The water lilies that bob in the stream signify purity of heart. In her hand is the passionflower, the bloom of a climbing vine that was known as the "floral apostle" for its associations with the crucifixion of Christ. Native to South America, the *passiflora coerulea* came to Europe with the return of Jesuit missionaries, who linked the parts of the striking white blossom streaked with purple to "the terrible paraphernalia" of the Passion of Christ. The corona resembled the crown of thorns, the five stamens represented the wounds, the three styles stood as the nails, and the tendrils recalled the scourges. A line from Psalm 113, "I meditate on all Thy works; I muse on the work of Thy hands," which Collins presented with the work when it was exhibited at the Royal Academy, underscores the floral discourse. Through nature and its iconic flowers, the novice learns her lessons of piety and confirms her commitment to her calling.

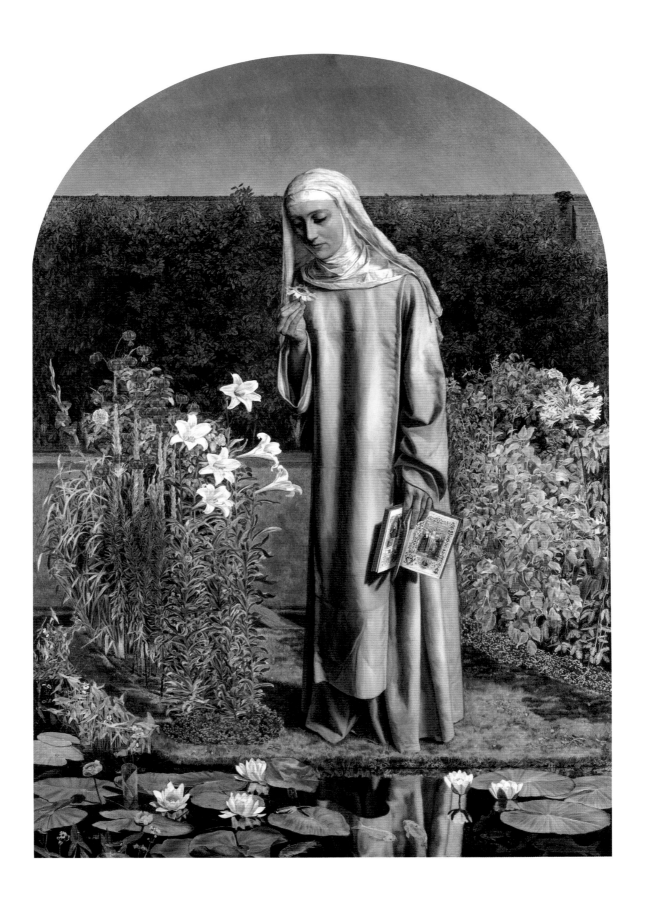

Titian Preparing to Make His First Essay in Colouring 1857

William Dyce (1806–64)
Aberdeen Art Gallery

Although John Ruskin was the first critic to defend the startling new aesthetic of the Pre-Raphaelite Brotherhood, he owed a debt to William Dyce for bringing their work to his attention. While enrolled at the Royal Academy schools, both Hunt and Millais had studied life drawing with the prominent academic painter, and all the young Brothers admired Dyce's leadership in reviving the art of fresco for the decoration of the interior chambers of the new Palace at Westminster. Ruskin recalled that at the 1850 Royal Academy exhibition, Dyce "dragged me literally up to the Millais picture…and forced me to look at its merits." Ruskin's forceful letter to the *Times* in the following year helped the public to comprehend the Brotherhood's recognition of nature as the supreme standard for their art. And soon the young artists' influence had an effect on their older master, as seen in the meticulous attention to botanical detail in Dyce's painting *Titian Preparing to Make His First Essay in Colouring*.

Dyce imagines a scene from the Venetian artist's boyhood. Young Titian sits transfixed before an old, elegant statue of the Madonna and Child raised on a rough tree stump in a neglected cottage garden. His abandoned cap and walking stick indicate that he had been out on a sketching tour, but the open pages of the sketchbook remain blank. Heaped in a basket at his feet are masses of flowers, and his intense gaze at the stark surface of the statue, as well as the blossoms he holds in his hand, reveal his plans. Titian will use the colors of nature, pressed from the petals of the flowers he has gathered, to add beauty to his art. The vignette evokes Ruskin's dictum "Truth to Nature," but at the same time recalls an older observation, that of Dante, who exclaimed "Nature is the art of God."

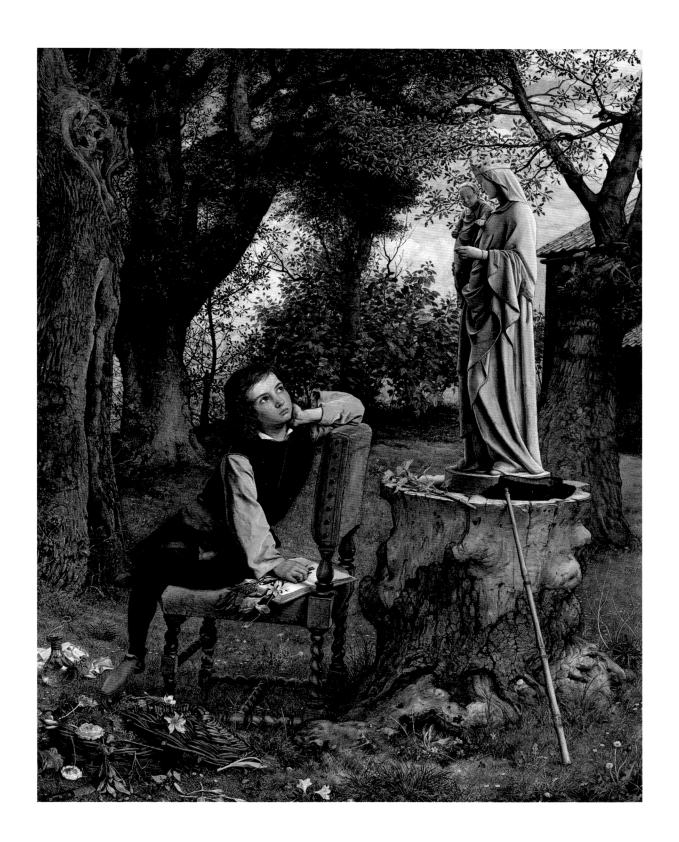

Broken Vows 1856

Philip Hermogenes Calderon (1833–98)
Tate Gallery, London

The garden, with its surrounding walls and sweet-scented flowers, was seen as a haven for lovers. Away from prying eyes, but well within the boundaries of strict courtship etiquette, couples could enjoy a rare moment of pleasurable privacy. But the taint of breaking the rules caused pain rather than pleasure as seen in Philip Hermogenes Calderon's *Broken Vows*. A scene of flirtation can be glimpsed through a crack in the fence. A man coyly dangles a pink rosebud, just beginning to bloom, above the upturned face of a pretty blonde woman. On the other side of the fence, an anguished woman swoons and grasps her heart. The garden wall, meant to hide her faithless suitor's dalliance, becomes her only support in her time of need.

Floral symbolism adds poignancy to this melodramatic narrative. The ivy that clings to the garden wall and frames the tormented woman is a tribute to her steadfast character. The pink rosebud represents new love, but it also marks the man's nature as fickle, for, as Walter Scott observed, "The rose is fairest when, 'tis budding new." Just to the right of the hem of the dark-haired woman's skirt is a tarnished bangle–a gift from her disloyal suitor–and the dull metal contrasts with the dewy petals of the rose. Even more telling is the faded iris that grows in the left foreground. Named for the messenger of Olympus, the iris had an ancient legacy as a warning to be heeded. But it was also associated with lost love and silent grief, for it was Iris who led young girls into the afterlife. The dry petals recall the lines of poetry by Henry Wadsworth Longfellow that accompanied the painting when it was first exhibited: "More hearts are breaking in this world of ours/Than I could say…Who hears the falling of a forest leaf?/Or who takes note of every flower that dies?"

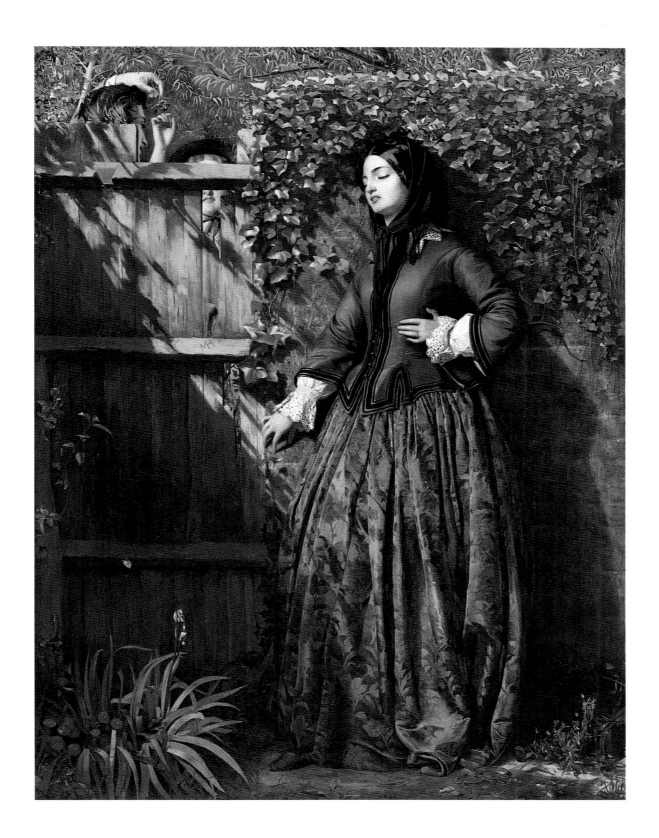

Ophelia 1851–52

John Everett Millais (1829–96)
Tate Gallery, London

Of all of Shakespeare's heroines, Ophelia was the compassionate favorite of Victorian audiences. Her trusting nature embodied current ideals of young womanhood, while her descent into delusion made her one of the most pitied figures in English literature. Her poignant demise had fascinated artists before John Everett Millais took up the subject, but his decision to present the scene of her death in painstaking detail shocked the critics. The writer for the *Athenaeum* labeled Millais's imagination as "strangely perverse," noting that while he "robs the drowning struggle of that love-lorn maiden of all pathos and beauty," he "studies every petal of darnel and anemone floating on the eddy." But to Millais, fidelity to botanic detail was an essential feature in the interpretation of Ophelia's tragedy. Her withering flowers forecasted her doom, and when her seemingly senseless chatter gave way to deathly silence, they gave pitiful testimony to all that she had lost.

In Shakespeare's *Hamlet* Ophelia's drowning takes place offstage, but Gertrude, who had witnessed the event, gives a horrified account. Millais followed every detail, from the "weedy trophies" in Ophelia's hand to her gown "spread-wide" that buoyed her as she floated in the rushing current. Every plant Gertrude mentioned—the willow, the nettle, the daisy—is clearly rendered, and their meanings—mourning, pain, and innocence—express a chorus of lament. Recalling her last mad appearance at the court, Millais scattered pansies on Ophelia's dress and gave her a necklace of violets. He also placed a poppy among the flowers in her hand, announcing that her journey would end in death. With ardent attention to painting the flowers over the course of four months of concentrated work, Millais left no doubt as to their significance: their message, like Gertrude's words, reflects on the fragile nature of innocence when forced to venture unprotected into a heartless world.

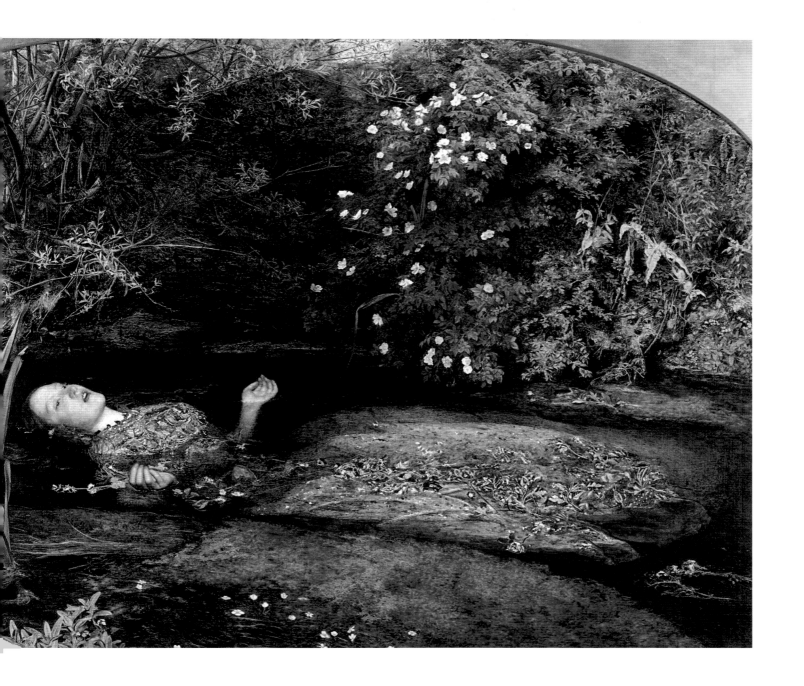

"Fantastic garlands did she make
Of cornflowers, nettles, daisies"

Hamlet act 4, scene 7

Ophelia 1894

John William Waterhouse (1849–1917)
Schaeffer Collection, Australia

The first evidence of Ophelia's madness went unnoticed. After Hamlet murdered her father, she began to wander aimlessly through the countryside, collecting flowers to make her ragged bouquets. When her brother Laertes returned to the court to plot revenge upon Hamlet with Claudius, Ophelia interrupted their meeting, singing childish songs and distributing her flowers. She handed out rosemary for remembrance, fennel for flatterers, columbine for fools, and pansies for thought. She expressed regret that she had no more violets–a symbol of modesty–explaining that "they withered all when my father died." The wildflowers and their folkloric meanings became her emblems, but they also betrayed neglect on the part of those who should have protected her.

John William Waterhouse painted Ophelia three times in his career. He first depicted her as prone in a meadow in 1889, and in his last version of 1909 he portrayed her distraught, running through the woods. By contrast, this painting of 1894 shows a serene Ophelia. With her eyes closed, she sits near the river on a fallen tree trunk, fastening a garland of poppies and daisies in her hair. A symbol for innocence, the common name for daisy in Elizabethan England was "day's eye," and it signified virtue, demonstrating worth in even the smallest of God's creations. When Ophelia exclaims, "There's a daisy," she calls attention to her own untainted simplicity. The poppies forecast her coming death, but like the pure white lilies that float on the water, she is still untouched by the muddy mire that lurks beneath the glassy surface. The moment in which she hovers between her descent into madness and her ghastly doom was regarded by the Victorian audience as supremely poignant, an echo of Edgar Allan Poe's chilling observation, that the death of a beautiful young woman was "unquestionably the most poetical topic in the world."

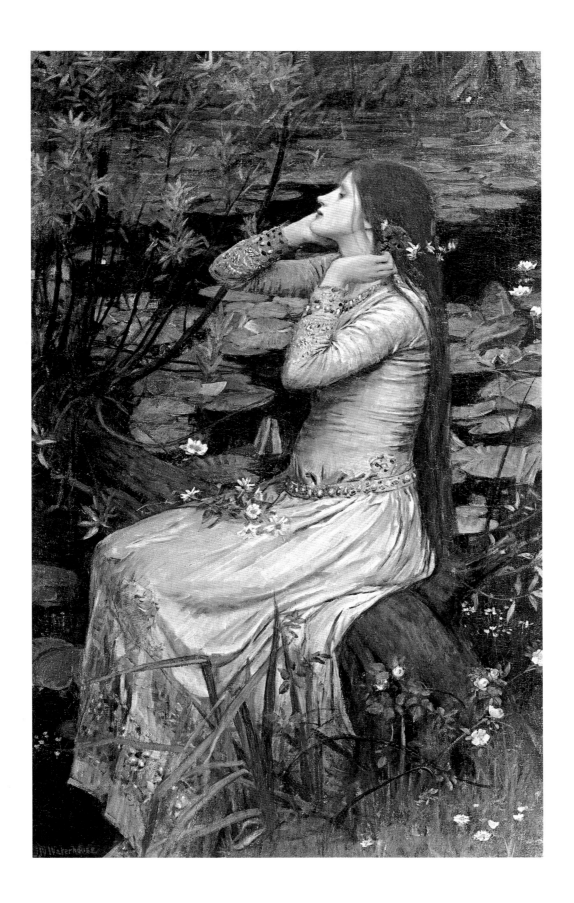

The Letter: Portrait of a Girl in a Violet Dress

c. 1860

Arthur Hughes (1832–1915)
Ashmolean Museum, Oxford

Lost in thought, this demure young woman, dressed in deep violet, sits with her back to the garden wall, her lap filled with pansies. Hughes's choice of flower calls attention to the depth of her reflection. The popular name "pansy" for the *Viola tricolor* derives from the French *pensée* or thought, and Ophelia echoes this association when she exclaims: "There is pansies, that's for thought." In Shakespeare's day, the pansy had other meanings as well. In A *Midsummer Night's Dream*, Oberon, the king of the fairies, declares that the pansy was once as white as milk, but pierced by Cupid's arrow, it turned "purple with love's wound." As his wife Titania sleeps, Oberon touches her eyelids with the juice from the flower's stalk, in the belief that the liquid had the power to instill passion in her heart for the first creature she would see upon waking. Many of the older names for pansies–love-in-idleness or kiss-me-quick–suggest wanton affection, but in the Victorian era, the small pansy was best-known as "heartsease," and it symbolized the tender concerns of loving attachment.

The unidentified sitter in Hughes's portrait holds a pansy in her right hand and clasps a folded letter to her breast with her left. A wistful expression clouds her face, stirred no doubt by the letter's words. Anna Pratt, author of the popular book of floral lore, *Flowers and Their Associations* (1840), describes a French practice in which a woman creates a token for a dearly loved friend: a bouquet of marigolds–signifying cares–and pansies, accompanied by the motto "May they be far from thee." With its Victorian message "You occupy my thoughts," the pansy embodied the unselfish virtues of concern and compassion that were regarded as natural qualities of the feminine heart.

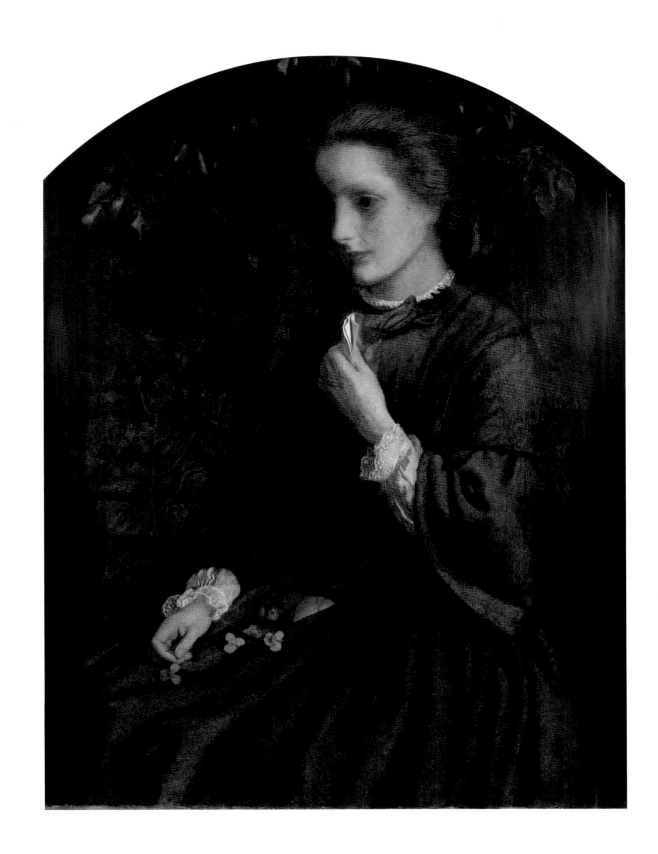

Forget Me Not 1901–02

Arthur Hughes (1832–1915)
Private Collection

A charming story reveals how the *Myosotis* earned its common name. In the Garden of Eden, God gave Adam the privilege of naming the plants and animals, but when he thought his task was done, a tiny voice cried out that it had been neglected. Declaring that although he had overlooked the little blue blossom once, Adam vowed never to do so again and gave it the name "forget-me-not." In the medieval era, popular lore connected the flower with chivalry and romance. According to a legend that has sources in several national traditions, a knight was walking with his lady by a rushing river when she called his attention to a beautiful bunch of flowers tossed upon the waves. He impulsively reached out to get them for her, but the weight of his armor pulled him beneath the water, and he called to her in a plaintive farewell, "Forget me not." As the centuries passed the little flower took on the character of earnest optimism, and in *The Keepsake* (1817), Samuel Taylor Coleridge's meditations on an uneasy heart, the "bright-eyed flow'ret" blooms as "Hope's gentle gem."

Like the tiny flower, the young woman in Arthur Hughes's painting *Forget Me Not* desires only to be remembered. As the last of the evening light streams through her bedroom window, she lifts her head as if to send her thoughts to a loved one far away. The small blue blossom in her hand speaks of her modest hope that she will not be overlooked or forgotten. She has chosen it from the field daisies and the wild roses that trim the little cap on the floor just to the left of where she kneels. Made for a young man, and now embellished with flowers that speak of new love, the cap leaves no doubt about whom she is thinking, as well as the innocent wish that he return her tender regard.

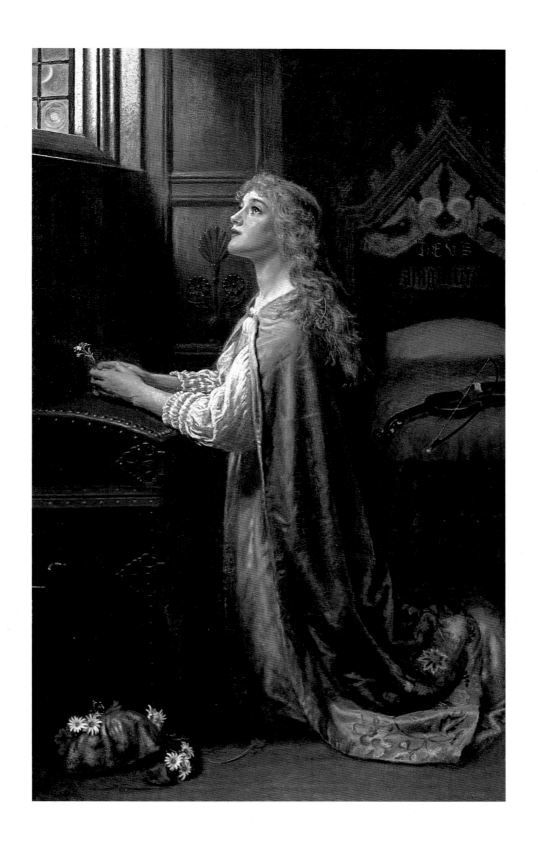

The Bridesmaid 1851

John Everett Millais (1829–96)
Fitzwilliam Museum, Cambridge

In the poem *Ode to Memory* (1830), Alfred Tennyson compared the rush of sweet recollections to a bridal procession "With music and sweet showers/Of festal flowers." As the favored floral emblems of the day, fashionable Victorian brides enhanced their appearance with wreathes of orange blossom and jasmine. This tradition had a romantic origin. It was believed that the Crusaders adopted the practice from the nuptial rituals of "ancient Saracens" when they celebrated their own weddings upon their return to Europe. While the headier perfume of jasmine hinted at wedded bliss, the waxy white petals of orange blossom reminded the assembled guests of the bride's chastity. According to Elizabeth Wirt's *Flora's Dictionary* (1829), the orange blossom paid a high compliment: "Your purity equals your loveliness." Bridesmaids wore orange blossom as well. Pinned to their gowns, a sprig of the fragrant flower drew attention to their own nubile charms, and in an era that prized matrimony over all other paths in a woman's life, orange blossom symbolized the bridesmaid's hope for her own happy future.

This ardent longing for matrimonial fulfillment is the subject of John Everett Millais's *The Bridesmaid*. Her golden silk gown, embellished with a spray of orange blossom tied with a white satin ribbon, indicates that the bridesmaid has just served at a wedding, but now, in the privacy of her room, she has loosened her hair, and she dwells on the course of her own destiny. On the table before her is an orange, a fruit long associated with brides and fecundity, as well as a piece of the bride's cake. Following an old folk tradition, the bridesmaid passes a morsel of the cake through a ring. She will then place it under her pillow, to guarantee dreams that will conjure the face of her intended partner.

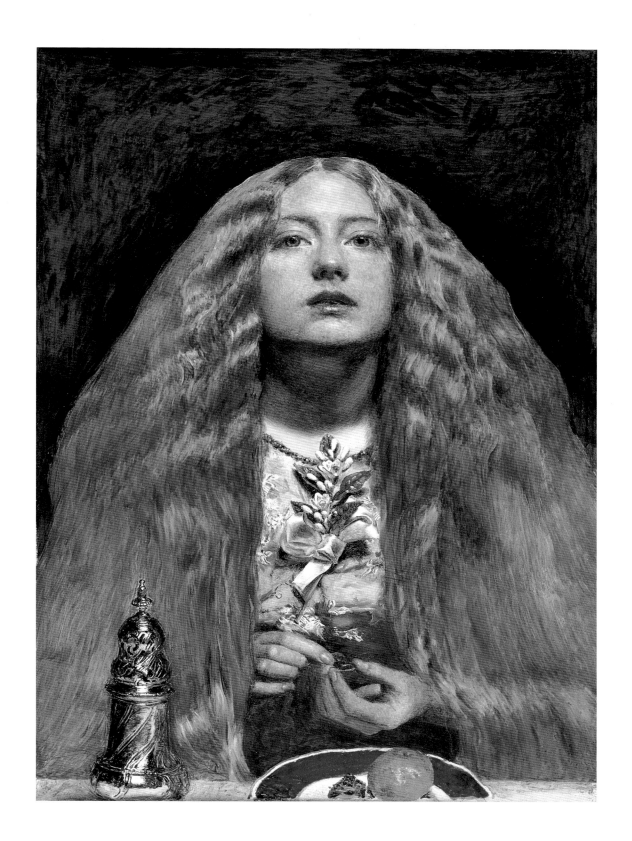

Spring (Apple Blossoms) 1859

John Everett Millais (1829–96)
Lady Lever Art Gallery, Port Sunlight

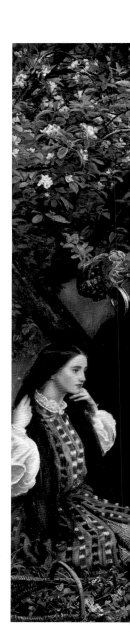

In northern climates the blooming of fruit trees signals the beginning of spring. The apple tree comes into early blossom with the onset of the strengthening sun, and its opalescent flowers, as exquisite as they are short-lived, are tinged with a faint pink blush. The stand of trees in full flower in John Everett Millais's *Spring* heralds the coming season, but it also symbolizes the stage of life of a group of girls who have gathered for a picnic near the low orchard wall. Like the shimmering petals that adorn the trees, the girls' youthful beauty is in a state of transience. They are no longer children, but they are not yet women, and, like the cool white petals that are touched with warmer tones, their girlish innocence is tempered with the recognition of their burgeoning womanhood.

The heavy gowns and jackets worn by the girls protect them from the lingering season's chill, but the rising spring sun has brought wild flowers as well as the apple trees into bloom. Their festooned hair and filled baskets reveal that the girls have come out to the field to pick these early blossoms, and the flowers they have chosen represent young women's virtues and the emotions of young love. The violet and the cowslip, emblems of modesty and thoughtfulness, prepare the girls for love's initial affections, represented by the lilac, while the campanula, or little bluebell, announces that they possess the power to be constant and true. But a more ominous note is struck by the scythe that leans against the wall to the right of the gathering, turning Millais's celebration of youth and beauty into an elegy. Even in the full flower of spring, the harvest looms on the horizon, and like the wild flowers that wither once they are plucked, delicate girlhood is evanescent, fading even as it blooms.

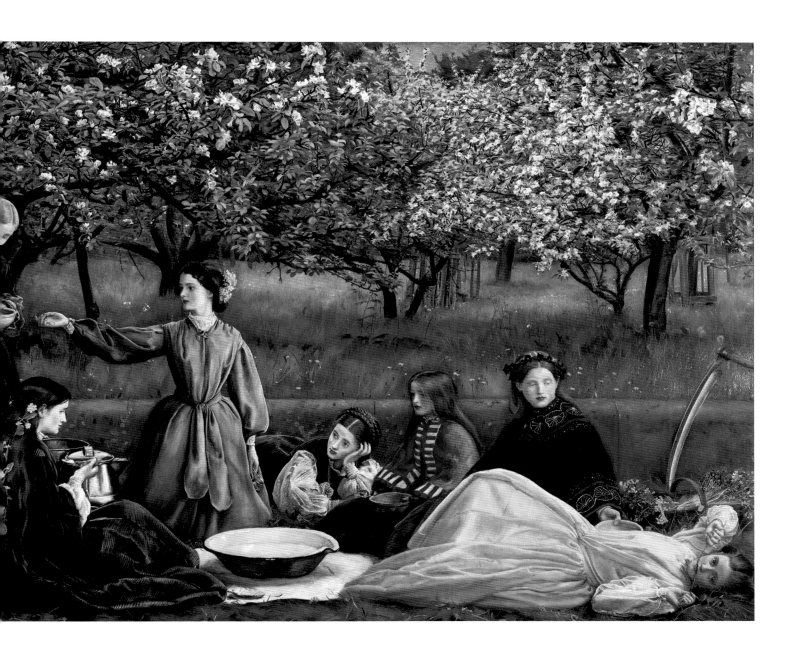

The Girlhood of Mary Virgin 1848–49

Dante Gabriel Rossetti (1828–82)
Tate Gallery, London

The Girlhood of Mary Virgin, the first painting to be exhibited as the work of the "PRB," reveals Dante Gabriel Rossetti's strong initial allegiance to Pre-Raphaelite aims in art. The subject–Anna observing her daughter Mary as she embroiders a lily on a scarlet banner–connected Rossetti's work with that of early Italian artists, such as Giotto, who illuminated the life of the Virgin in a series of scenes from her birth through her death. By imagining the Virgin as a young girl Rossetti fulfilled his goal of having "genuine ideas to express." Like many in his generation, Rossetti regarded Mary as an example of ideal womanhood, describing her as "a symbol of excellence … at its highest type." His sister Christina posed for the Virgin, and his mother sat as Anna. The critic for the *Athenaeum* explained that Rossetti was "young in experience," but that he possessed "true mental power," in which his art "is the exponent of some high aim."

As in the practice of the Northern Renaissance masters, Rossetti invested each object he painted with symbolic significance. The grape arbor, tended by Mary's father Joachim, forecasts the Eucharist, while the bound palms at her feet predict the martyrdom of Christ. The dove that perches on the trellis proclaims the presence of the Holy Spirit and calls attention to the single pink rose, an emblem of Mary's distinction among all other women. Of all the symbols, Rossetti gives the tall white lily with its triple bloom special prominence. In the poem that Rossetti wrote to accompany the painting he describes young Mary as "An angel-watered lily, that near God/Grows and is quiet." In the painting, the lily serves both as the model for Mary's needlework and for her character, as it denotes her signal virtues of stainless purity and perfect innocence.

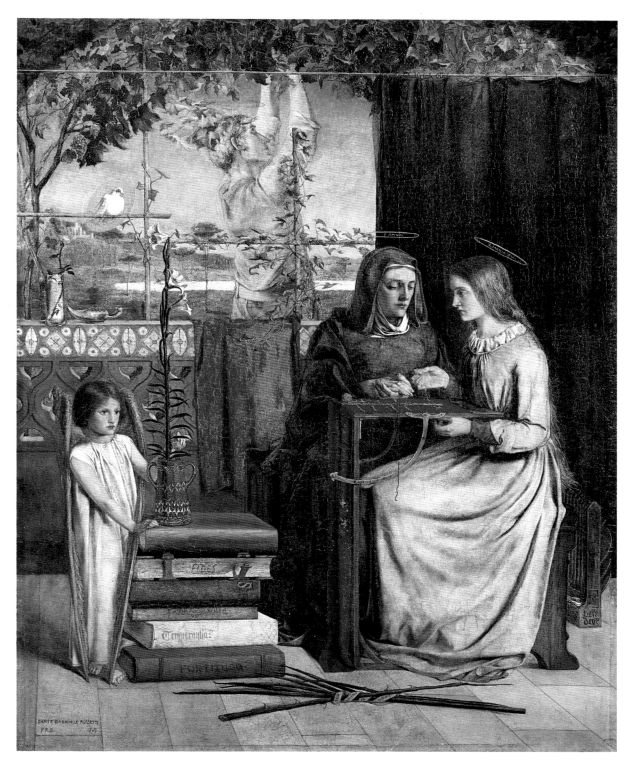

*"And lilies white, prepared to touch
The whitest thought"*

Elizabeth Barrett Browning, *Aurora Leigh*

Ecce Ancilla Domini 1849–50

Dante Gabriel Rossetti (1828–82)
Tate Gallery, London

In his poem *Mary's Girlhood (For a Picture)*, Dante Gabriel Rossetti envisions the morning that the archangel Gabriel came to Mary to announce her earthly role in the divine plan. Throughout her girlhood, she had been schooled in virtue– "Faithful and hopeful; wise in charity"–and on that morning when she rose at dawn, she "had no fear … and felt aw'd: Because the fulness of the time was come." *Ecce Ancilla Domini* presents Mary's moment of wonderment and awe. Gabriel enters her modest chamber on flaming feet, as the dove of the Holy Spirit enters through the window. He confronts Mary as she draws back in awe on her plain white bed and proclaims her God's hand-maiden with the words "Ecce Ancilla Domini." In his hand he carries a white lily with two full blooms for God and the Holy Spirit and one opening bud for the unborn Christ.

The white lily or *Lilium candidum* was first associated with a fifth-century legend of Mary's Assumption. The apostles found her open grave filled with roses and lilies, giving material form to the metaphor of purity and beauty in the Song of Solomon: "I am the rose of Sharon and the lily of the valley" (2:1). In the eighth century, the English Benedictine monk Bede remarked that the lily resembled Mary, its white petals signifying her untouched chastity and the golden anthers reflecting the divine light in her soul. Early painted images of the Annunciation represent Gabriel holding a sceptre or an olive branch, although there is no reference to either in the account in Luke (1:26–38). By the end of the fifteenth century, Italian artists, notably Leonardo da Vinci and Botti-celli, portray Gabriel holding the lily with its triple bloom. Rossetti adopts this tradition, and Mary's embroidered banner at the foot of her bed promises the fulfillment of her mission with all three lilies in full flower.

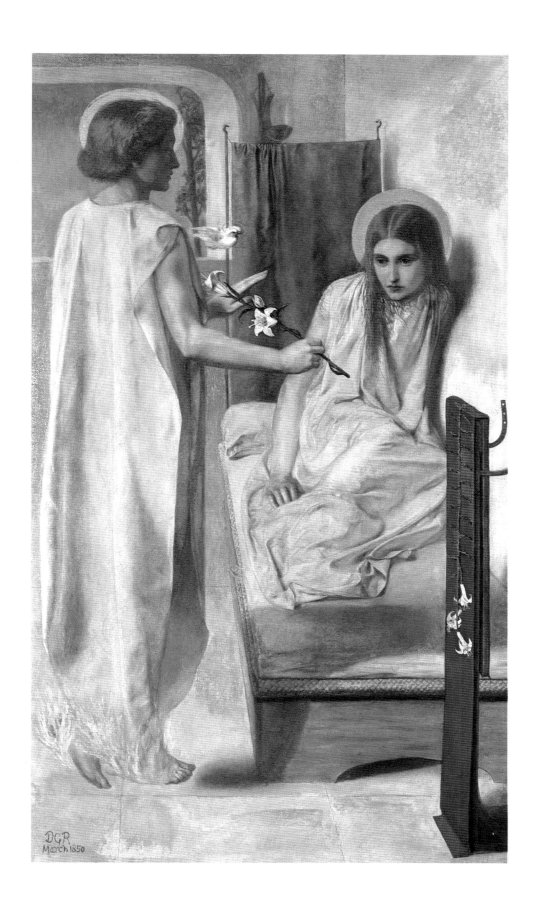

The Annunciation 1857–58

Arthur Hughes (1832–1915)
Birmingham Museums and Art Gallery

Arthur Hughes conceived his painting *The Annunciation* as part of a pendant series on the life of the Virgin. The second work *The Nativity* appeared a year later, and although the sizes and arched formats of the compositions are identical, the humble aesthetic of *The Nativity*, with its earthy colors and spare setting, contrasts with the ethereal atmosphere of *The Annunciation*. With a shimmering palette of lilac and pale gold, Hughes casts a rarified aura on his scene of Gabriel's visit. The Archangel pauses on the threshold of Mary's chamber. His arms are crossed over his chest in a gesture of homage, and the way his magnificent wings are wrapped around his legs suggests that he has just fluttered to a standstill. Mary rises from the bench where she had been spinning scarlet yarn. Clutching the spindle to her chest, she bows her head in reverential awe, awaiting the words of the divine messenger.

Although Gabriel does not speak, the flowers that accompany him convey his message. Lilies bloom in profusion at his feet, evoking the lines from Matthew 6:28: "Consider the lilies of the field, how they grow: they toil not neither do they spin." Rather than idleness the passage comments upon mystical surrender, instructing Mary to emulate the lilies and give herself over in trust to God's grace. Just inside the doorway is a tall urn holding stalks of purple iris. In Christian iconography the traditional floral herald gave the announcement a sorrowful aspect. A French medieval legend claimed that until Christ's death all irises had petals of gold. On the night of the crucifixion, the glittering gilt faded into purple as a sign of everlasting mourning. The pairing of the lily and the iris notes Mary's acceptance of her mission, even if the joy of new birth will be subsumed into inevitable sorrow.

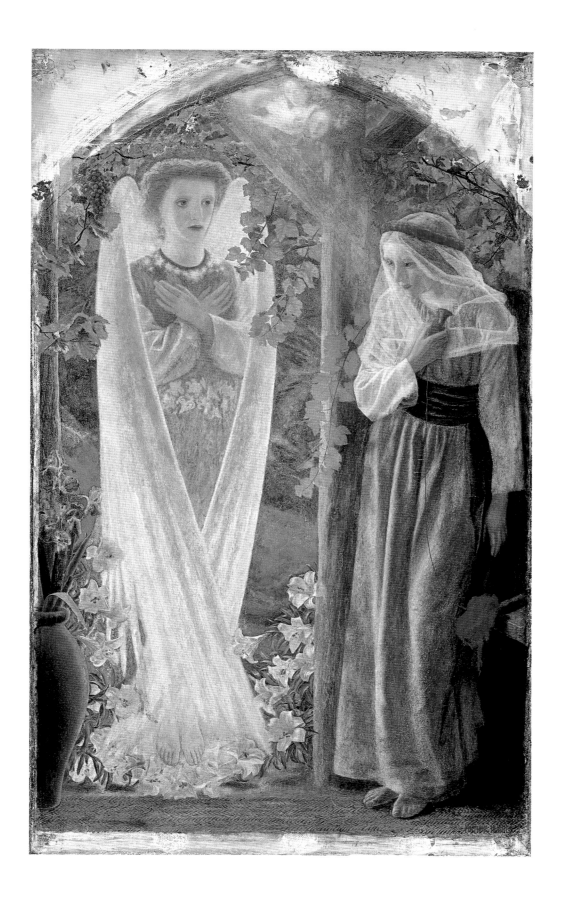

The Blessed Damozel 1875–78

Dante Gabriel Rossetti (1828–82)
Fogg Art Museum, Cambridge, Mass.

Dante Gabriel Rossetti was a young man when he created the Blessed Damozel in a poem that was published in the Pre-Raphaelite journal, *The Germ* (1850). A celebration of passion that transcends death, the poem describes the ardent devotion of a man to his deceased beloved who waits for him to join her in eternity. She is a patient guardian, watchful for the sake of her lover's soul as she leans out "From the gold bar of Heaven." Her attributes—seven stars in her hair and three lilies in her hand—signify her rightful place among the angels, and the single ornament she wears—a white rose that graces her open robe—was given to her by the Virgin Mary for her compliant service. But in this sacred portrait Rossetti instills a sensual undercurrent. The Damozel's eyes have a greater depth than still waters. Her golden hair recalls ripe corn. And, as her earthly lover reflects upon her vigil, he imagines that her supple body "must have made/The bar she lean'd on warm."

More than two decades later Rossetti returned to the subject of his poem in this painting. He faithfully creates her iconography: She leans upon a golden bar. Stars encircle her head in a halo, and she holds a triple-blossomed Madonna lily in her hand. Her earthly lover, confined in the predella panel, languidly returns her gaze, dreaming of the day when she will comfort him like the lilies, which "lay as if asleep/Along her bended arm." To this Rossetti adds a pair of angels holding martyr's palm fronds, and behind the Damozel are pairs of lovers, embracing in eternal union. The pink roses that surround her venerate her as the object of earthly as well as heavenly desire. Years later, Rossetti's sister Christina would observe that "Love wears the Lily's whiteness, and Love glows in the deep-hearted Rose," and by pairing the flowers as the Damozel's emblems, Rossetti declares that love merges the passions of the sacred and the profane.

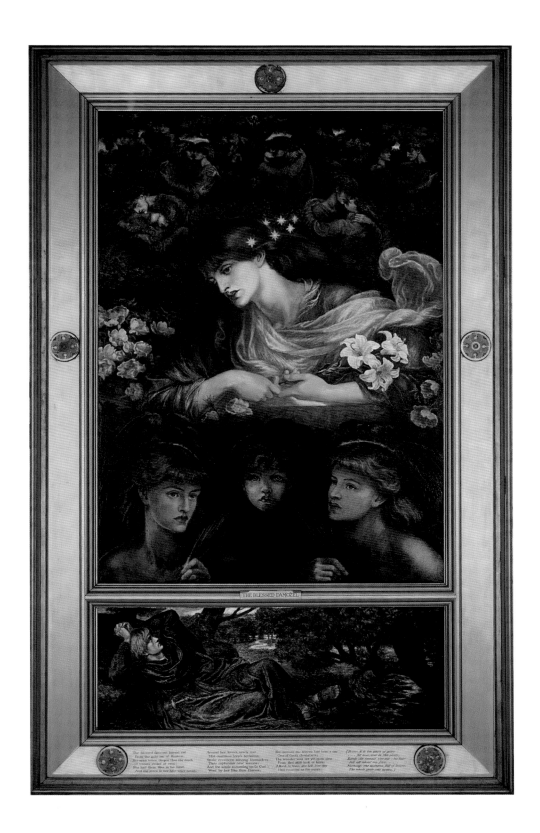

Elaine 1870

Sophie Anderson (1823–1903)
Walker Art Gallery, Liverpool

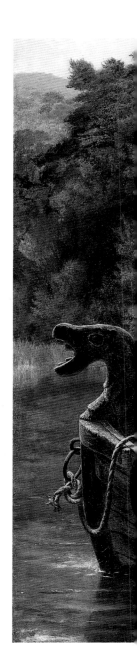

Alfred Tennyson introduced the most fragile figure of his *Idylls of the King* as an ideal of chaste girlhood: "Elaine the fair, Elaine the loveable,/Elaine the lily maid of Astolat." Beautiful, charming, and devoted to her brothers and her widowed father, Elaine lived in a state of peaceful innocence until a woman's passion stirred her immature heart. Originally published as *Elaine* in 1859, one of the first four poems written in the twelve-part Arthuriad that would occupy the poet laureate through the rest of his life, *Lancelot and Elaine* presents the tragic results of misguided and unrequited love. Until Arthur's greatest knight arrived at Astolat, Elaine was a perfect daughter: sweet, industrious, and obedient. But Elaine mistook Lancelot's courtly behavior for romantic attraction, and she fell hopelessly in love with him. More than three times her age, and obsessed with his own passion for Guinevere, Lancelot neither encouraged nor accepted her adoration. Starved of love, Elaine turned to death "like a friend's voice," and she asked her brothers to place her in a boat that would carry to Camelot, where, arrayed like a queen with a lily in her hand, she would confront her beloved's rejection.

 Although not a member of the Pre-Raphaelite circle, Sophie Anderson followed their aesthetic standards in painting the "lily maid's" journey. Lying in state under her golden coverlet, Elaine's cold skin is as white as the Madonna lily in her rigid right hand. Her only mourner is the aged boatman who can neither hear nor speak, but upon her arrival at the court, the letter in her left hand explained her tragic demise. Deeply moved, Arthur ordered a tomb for her, embellished with a lily and Lancelot's shield, so that the emblem of a girl's naive purity would endure as a caution for the worldly to protect the innocent.

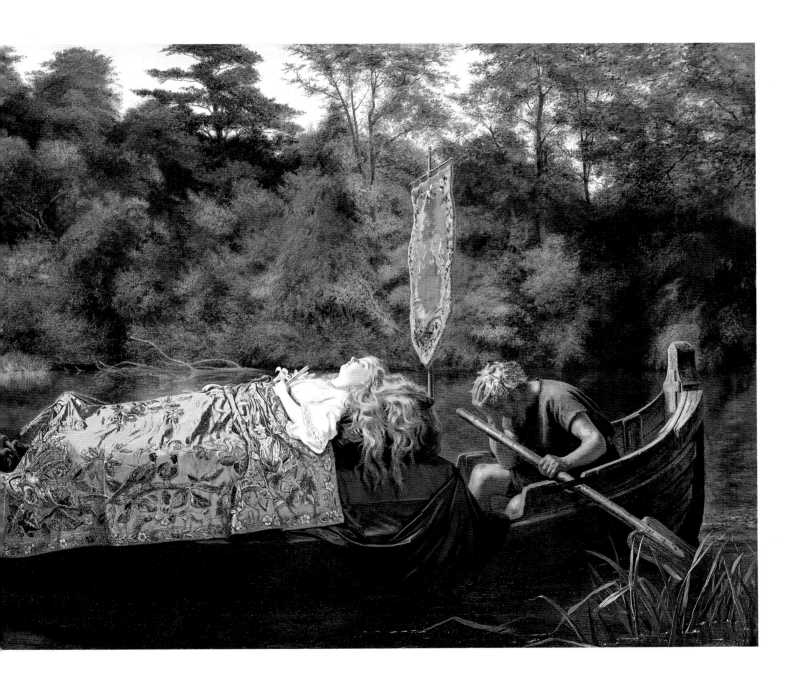

The Beloved (The Bride) 1865–66

Dante Gabriel Rossetti (1828–82)
Tate Gallery, London

Within a circle of sultry women, the title figure of Dante Gabriel Rossetti's *The Beloved* draws back an emerald-green head scarf to reveal her porcelain skin and russet hair. The contrast of her fair appearance with the exotic allure of her dark-haired attendants is at the center of this meditation on beauty and luxury. Rossetti took his inspiration from the Song of Solomon, and he inscribed "My Beloved is mine and I am his" (2:16) on the frame. With these words are lines from Psalm 45: "The Princess is decked in her chamber with gold-woven robes;/in many colored robes she is led to the king" (13–14). The rich display of physical beauty and material luxury was meant to stir the senses. The beloved bride is wrapped in a sumptuously embroidered robe, which was, in fact, a Japanese kimono draped around the model to close in the back. All the women wear jewels; burnished gold, shining rubies, and luminescent black pearls adorn their hair and encircle their wrists and necks. In advance of the procession is a small, black-skinned child who bears a golden chalice of pink and pale yellow roses, recalling that the bride of Solomon was praised as the "rose of Sharon" (2:1).

Contemporary floral lexicons list individual meanings for every variety of the rose. The damask rose praised a woman's brilliant complexion, while the multiflora complimented her grace. With its abundant petals, the cabbage rose served as the ambassador of love, and the manner in which the child presents the rose-filled chalice suggests this meaning. Along with the Persian lilies, held aloft by the dark attendants, the floral offering of these full-blown roses—an emblem of a nubile woman—celebrate the sensual pleasures that accompany the sacrament of marriage.

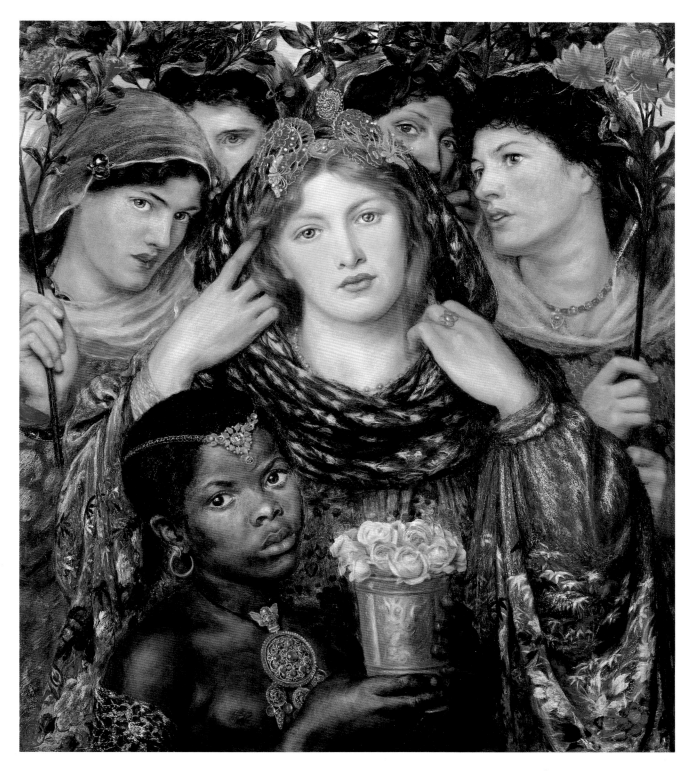

"But I will woo the dainty rose,
The queen of everyone!"

Thomas Hood, *Flowers*

La Ghirlandata 1871–74

Dante Gabriel Rossetti (1828–82)
Guildhall Art Gallery, London

In the early 1860s, Dante Gabriel Rossetti shifted his source of inspiration from the austere aesthetic of early Italian art to the opulent works of the masters of sixteenth-century Venice. Influenced by the examples painted by Titian, Tintoretto, and Veronese, Rossetti formulated a type now known as the "Venetian" painting, a half-length portrait of a beautiful woman in a closely confined space, surrounded by rare and luxurious objects. The titles of these works reveal that their real subject was sensual pleasure. Rossetti's new technique featured a rich display of color and a luminous handling of the oil paint; the array of objects presented with the woman were stripped of a narrative context and served only to complement her beauty. Rossetti used different models for his Venetian paintings, often melding their distinctive qualities into a singular ideal. Among them, he favored Alexa Wilding who possessed a placid expression and chiseled features that blended well with the supple textiles, glowing jewels, and abundant flowers that now filled his compositions.

La Ghirlandata takes its name from the garland of roses and honeysuckle that crowns the head of the harp. Tradition associated honeysuckle with affectionate devotion, and Rossetti, who equated devotion with passion, saw it as a symbol of sexual attraction. This is confirmed by the pink roses at the fullest extent of their bloom. The lush green velvet of Wilding's dress links her with the verdant foliage of the bower setting, as if her loveliness was a gift of nature. But the blue blossoms in the foreground strike an ominous note; poisonous monkshood warned of the approach of a dangerous foe. Rossetti's brother William later said that the discordant choice was an error, explaining that although the painter adhered to the language of flowers, he was "assuredly the reverse of a botanist." William asserted that his brother intended to paint larkspur, an emblem of lightness and levity.

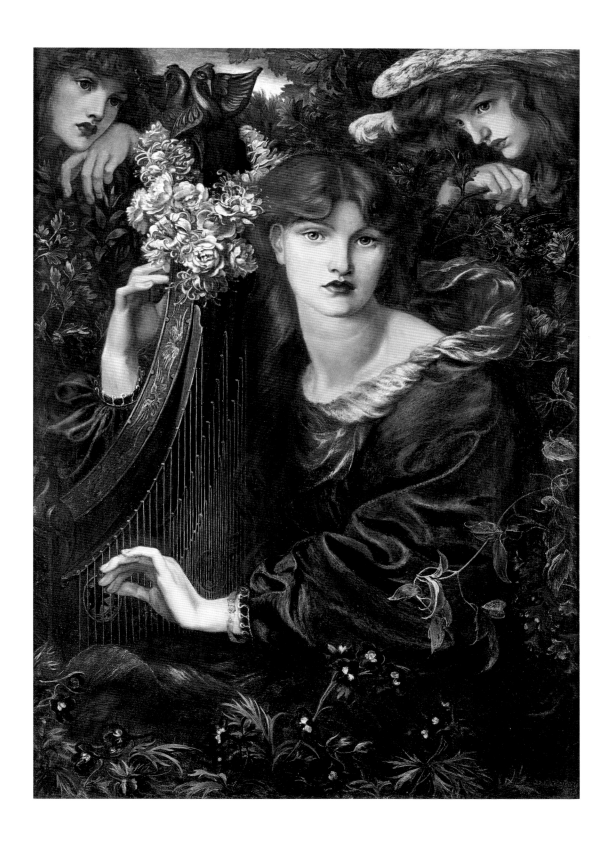

The Roseleaf 1870

Dante Gabriel Rossetti (1828–82)
National Gallery of Canada, Ottawa

In the twenty-eighth sonnet of the cycle *The House of Life*, Dante Gabriel Rossetti compared the beauty of his beloved to "genius." Her "sovereign face" incarnated "compassed mysteries," equaled in its profound expression only by the paintings and poems of the greatest masters of the ages. A true muse, her very existence fed his art, and even her "shadowed contour on the wall" cast a spell of love through its inspiration. Jane Morris, for whom the poem was written, reigned as Rossetti's muse in the latter half of his career. He always insisted that he was the first to appreciate her unusual appearance, and from 1865 until his death, her image held sway over his imagination. He found her quiet intensity, her dignified bearing, and her exaggerated features perfectly suited to portray the most mournful women of mythology and literature, and she posed for him as Pandora, Proserpina, and several of the sad but compassionate heroines in the writings of Dante. But during the years 1865 to 1870, Rossetti was determined to create the true image of the real woman who nurtured his highest artistic intentions. He wrote to Jane in 1870 of his desire to capture her likeness "once and for all so as to let the world know what you were."

The drawing Rossetti called *The Roseleaf* catches Jane in an unguarded moment, glancing back at him over her shoulder. Her dress is simple, and there are no attributes of material luxury to distract the viewer's attention from her beauty. She holds the stem of a rose, shorn of its thorns as well as its blossom, an emblem of dignity that declares "I will never beg you." Percy Bysshe Shelley's poem *Music, When Soft Voices Die* (1824) links the rose leaf with memory, like the thoughts that linger in a lover's absence. Jane's haunting beauty remained with Rossetti as long as he could render her likeness and summon up her image to guide his art.

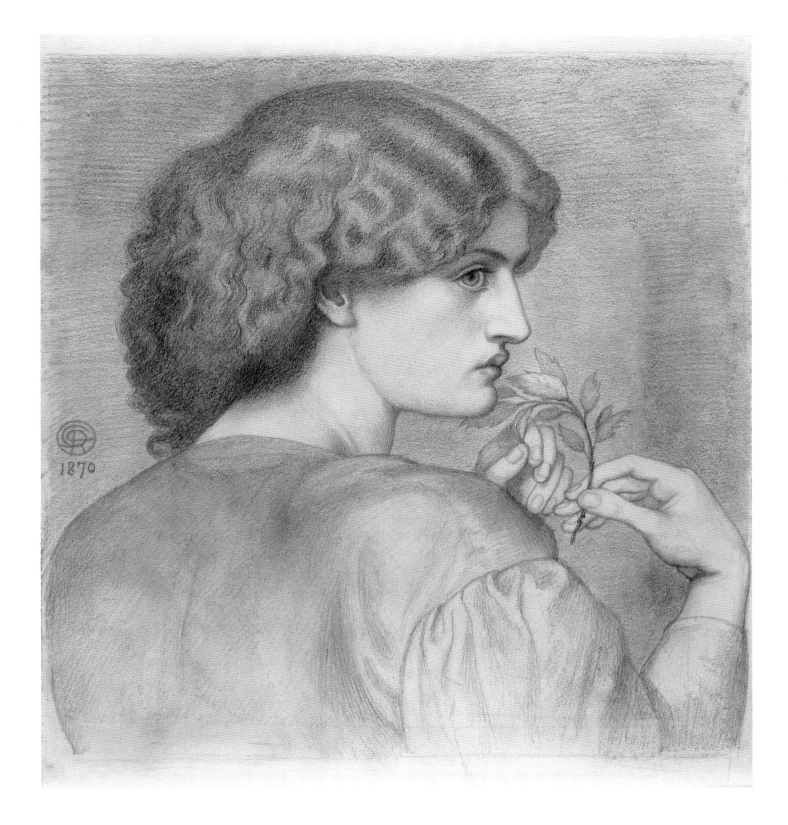

The Rose Bower from The Briar Rose Series

1884–85

Edward Burne-Jones (1833–98)
Faringdon Collection Trust, Buscot Park

In 1884, Edward Burne-Jones asked an odd favor from his friend Lady Leighton Warren. He wanted her to send him a stem of briar rose, "a hoary aged monarch of the tangle, thick as a wrist with long horrible spikes on it." For more than a decade, Burne-Jones had been fascinated with the Legend of the Briar Rose, an old French variant on the tale of Sleeping Beauty in which the whole court falls under a spell and slumbers for a century. A young knight encounters the castle by chance, now overgrown with a thicket of wild briar rose. Out of curiosity, he cuts through the brambles, and discovers the sleeping Princess; when he takes her hand she rises, and the whole court awakes. Charles Perrault had included a version of the tale in his *Stories or Tales of Times Past* (1697), and Alfred Tennyson offered his own interpretation in the poem *The Daydream* (1842).

After using the story for a tile design (1864) and an ensemble of three small canvases (1871–90), Burne-Jones was now working on a four-part series on a grand scale, depicting the knight entering the wood, the king and his ministers asleep in the council chamber, young women slumbering in the garden, and the Princess reposing on her bed, still as death. The sinuous stems of the briar rose twist through each composition and lead the viewer, along with the knight, to her chamber. With its treacherous thorns and delicate blossoms the briar rose symbolized sacrifice for love, bearing the traditional message, "I wound to heal." Although Burne-Jones ended his ensemble in the moment before the knight enjoys the rewards of his travail, he painted another aspect of the tale in a private set of sketches called *The Flower Book* (1882–98). Intrigued by the names of flowers, Burne-Jones began to make lists, and from these he invented imaginative illustrations. *Wake, Dearest!*, in *The Flower Book*, depicts the knight taking the hand of the Princess who gently stirs upon a bed entangled with briar rose.

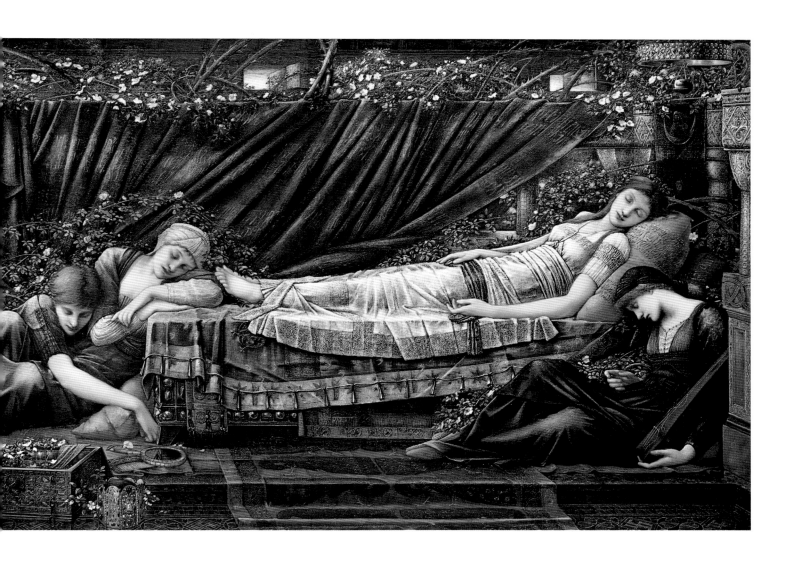

Heart of the Rose 1891

Edward Burne-Jones (1833–98)
Roy Miles Gallery, London

The first known version of the *Romant de la Rose* was written in the thirteenth century by Guillaume de Loris. The longer English poem known as the *Romaunt of the Rose* from the next century is generally attributed to Geoffrey Chaucer. Inspired by their mutual admiration for Chaucer, Edward Burne-Jones and William Morris collaborated on several projects in interior design and tapestry based on this allegory of the quest for perfect love.

In the guise of a dream, a poet meets the god of Love, who serves as his guide through a world of gardens, where they encounter personifications of the virtues and vices. In the garden of Narcissus, a reflection on the still water in a fountain catches the poet's eye. It is the image of a rosebud, and from that moment on he can think of nothing else but winning the heart of the rose. Love leads him on through all the stages of infatuation, encountering personifications of Jealousy, Danger, Shame, and Falsehood. But the poet ends his journey in the Garden of Idleness, reunited with the object of his desire.

Burne-Jones portrayed the poet crossing the threshold of the enclosed garden. A stand of iris–the floral herald–blooms just outside the garden wall, and the poet hesitates. But Love, holding a pilgrim's staff, grasps his hand and draws him deeper into the garden, where he can behold the rosebud in full blossom, an incarnation of a beautiful woman dressed in an emerald green gown. Iris grows near Love's feet, announcing the end of the quest. The Madonna lilies near the wall, behind the blooming rose bush, signify the purity of this love and its fulfillment. Although Burne-Jones refrained from joining the poet with his heart's desire, a poem that William Morris wrote to accompany the painting assures that in the end the poet "takes the branch, and takes the rose/That Love and he so dearly chose."

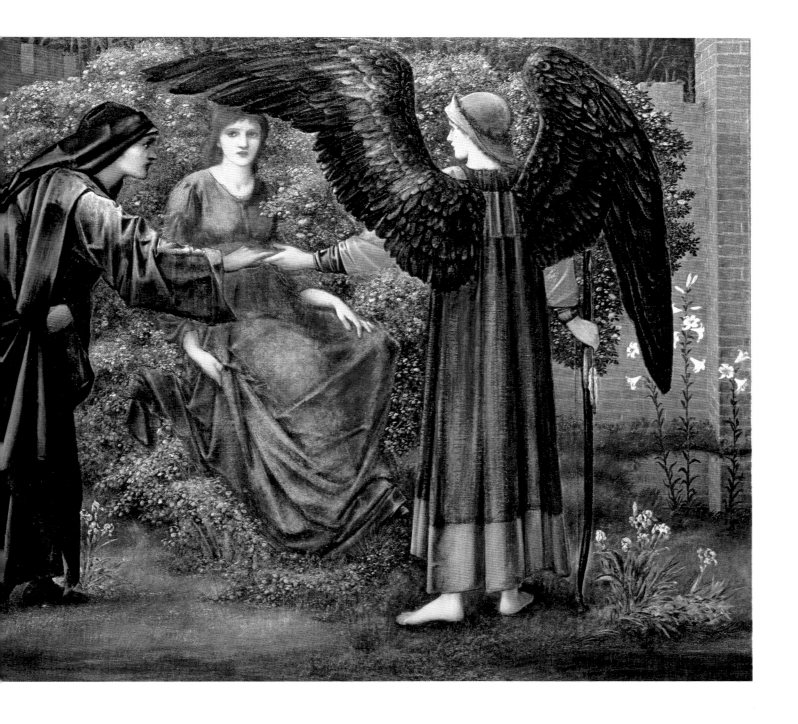

The Soul of the Rose 1908

John William Waterhouse (1849–1917)
Private Collection, Julian Hartnoll

Throughout his career, John William Waterhouse associated beautiful women with roses and wild flowers. He returned to this theme late in his life in a series of paintings that echo Rossetti's "Venetian" mode, each presenting a woman in a half-length portrait, dressed in sumptuous garments. Instead of the rare and luxurious objects that Rossetti paired with his ideal women, Waterhouse matched his with flowers. Although given suggestive titles, such as *Gather Ye Rosebuds While Ye May* and *Vanity*, these works transcend context and narrative, emphasizing instead the transitory state of young womanhood that parallels the beauty of the budding and blooming of the traditional flower of love.

In *The Soul of the Rose* a comely woman whose thick red hair is twined with pearls in an elaborate chignon, leans against a garden wall to inhale the fragrance of an opening rose. There is a air of poignancy in her action. She presses her hand firmly against the wall, and her neck arches and strains as she tries to draw in the very essence of the rose. Her skin is flushed and her expression is pensive, as if the fragrance has summoned a memory that brings both pain and pleasure. In the poem *Maud* (1855), Alfred Tennyson relates the musings of a man hopelessly in love with his enemy's daughter. As he pines in a rose garden, longing for the "Queen rose of the rosebud garden of girls," he speaks to the flowers, lamenting past opportunity: "And the woodbine spices are wafted abroad/And the musk of the roses blown." In spite of the insurmountable circumstances, he vows his fidelity in an oath to a rose, believing that "the soul of the rose went into my blood," with the words "For ever and ever, mine." Waterhouse's choice of title evokes this same sentiment of yearning. Fragrance arouses the senses, but also summons up memory, suggesting that love, like youthful beauty, is as transitory as the blossoming of a rose.

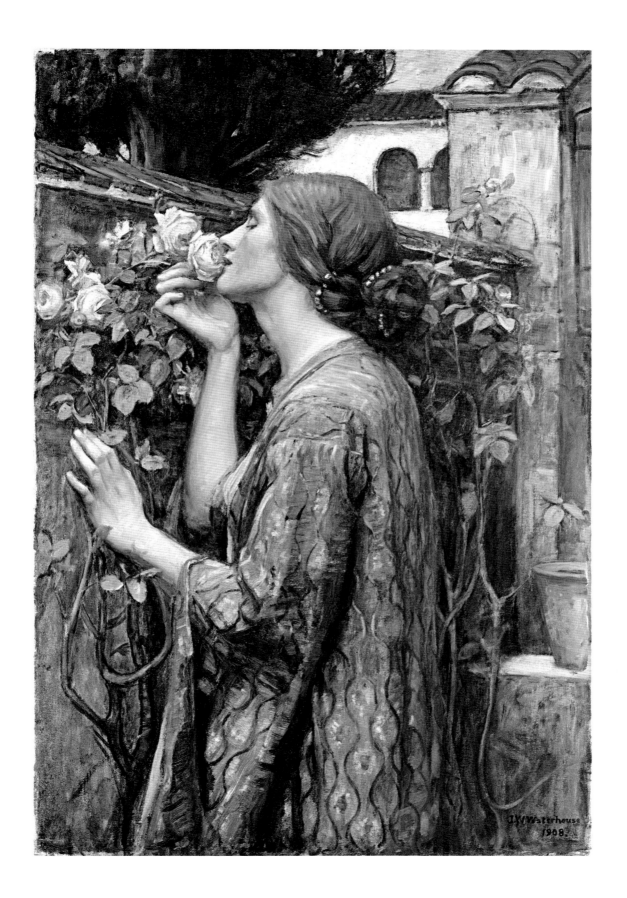

Venus Verticordia 1864–68

Dante Gabriel Rossetti (1828–82)
Russell-Cotes Art Gallery and Museum, Bournemouth

The title *Venus Verticordia* proclaims that the goddess of Love possesses the power to change the nature of the heart. Based in ancient Roman belief, this aspect of Venus's character originally had a moral emphasis, invoking women to turn their desire into virtue. But Rossetti's painting of the provocative goddess, surrounded by full-blown roses and fragrant honeysuckle, offers a different message. In her left hand, Venus holds the Apple of Discord, given to her by Paris as a tribute to her unparalleled beauty. She points Cupid's arrow—the symbol of love's pleasures and pains—directly at her heart. The butterflies that hover around these attributes and light upon her halo symbolize the fickleness of shifting affections. Above her a bluebird flutters its wings. Ancient classical lore asserted that the bird had a life span of a single day, and its appearance heralded bad luck, reminding humanity that life and love were fleeting. Rossetti's celebration of physical beauty is tempered by this cautionary iconography, warning of the danger hidden in sensual delight.

Rossetti used the full-blown roses as a conventional symbol, to signify that Venus's beauty was at its zenith. The floral lexicon written by his friend John Ingram cites generous affection as the honeysuckle's meaning, but French books link the flower to the bonds of love. To Rossetti, the open form of the blossom that was irresistible to bees suggested sexual attraction. In his poem *The Honeysuckle* (1853), the narrator climbs a thorny hedge, tearing his clothes and his skin to pluck a single wind-battered bloom, which he found "sweet and fair." The lavish depiction of the honeysuckle made the prim John Ruskin uncomfortable, and he declared that they held "enormous power" in their "coarseness." But the critic Frederick George Stephens was won over by the goddess's allure in this portrait that revealed her true nature to be "victorious and indomitable."

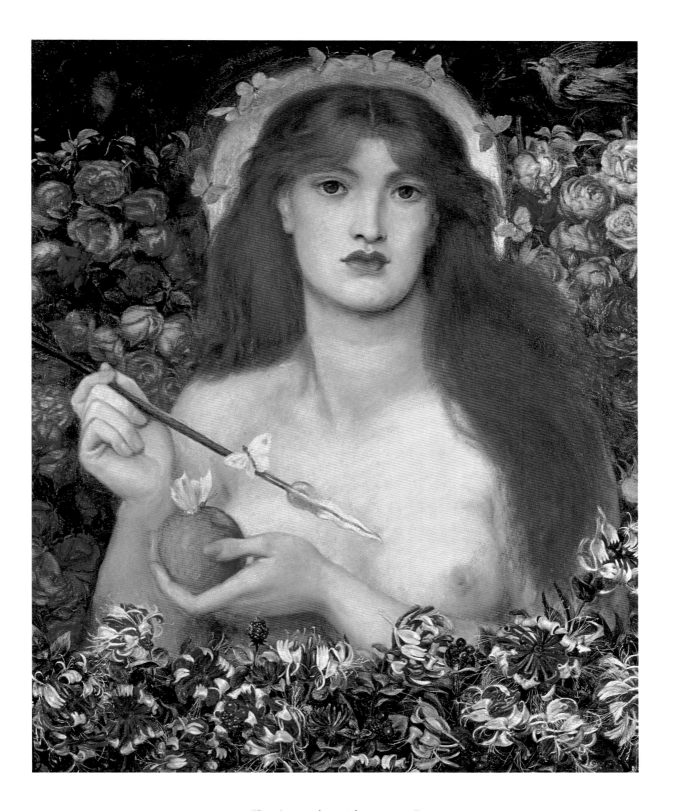

"Love's rose a host of thorns invests"

Percy Bysshe Shelley, *Love's Rose*

Vivien 1863

Frederick Sandys (1829–1904)
Manchester Art Gallery

In 1857 Alfred Tennyson printed and bound the first two poems of his *Idylls of the King* for six of his friends. Titled *The True and the False*, these poems told the tales of Enid, the most devoted woman in Camelot, and Nimüe, "the wiliest and the worst." After reading the second poem, Edward Burne-Jones felt compelled to ask the poet laureate to change Nimüe's name. Tennyson humored the young painter, and when the poems were published in the first volume of the *Idylls* he called that character Vivien. Her hatred of the king began at the moment of her birth; her father died in battle against Arthur's forces just as her mother died in childbirth. As she grew into womanhood, her stunning beauty hid her degenerate nature. Once established in Guinevere's circle of ladies, Vivien seduced Merlin. Besotted with her beauty, he schooled her in magic, but she trapped him with one of his own spells. Vivien proved to be a fatal woman; by imprisoning Arthur's mage, she brought on the first disaster that led to the fall of his kingdom.

Frederick Sandys envisioned *Vivien* as a haughty patrician beauty. The critic Esther Wood observed that despite her "stately and deliberate loveliness," Sandys's *Vivien* expressed the potential of "cold cruelty." The attributes in this painting confirm Wood's interpretation. The screen of exquisite peacock feathers signifies the vice of luxury, and the apple she holds near her rounded breast recalls humanity's fall from grace. She holds a dry rose in her hand, a symbol that love had died in her heart. She has paired the rose with a sprig of daphne. Traditional flower lore identifies the daphne with coquetry and the desire to please, but it was also widely known that every part of the flower was toxic, making the poisonous plant the perfect emblem for a *femme fatale*.

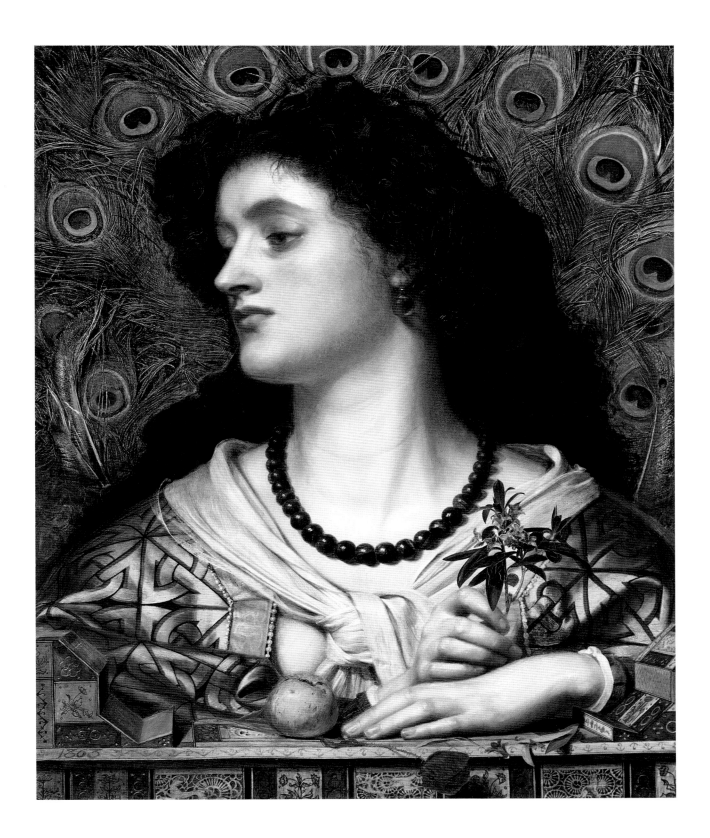

The Tree of Forgiveness 1881–82

Edward Burne-Jones (1833–98)
Lady Lever Art Gallery, Port Sunlight

Phyllis, daughter of the King Thrace, fell in love with Theseus's son Demophoön. He had stopped in her kingdom on his journey home from the Trojan War and pledged to return after a brief sojourn in Athens. But months passed, and with no word from Demophoön, Phyllis took her own life. To honor her sacrifice, Athena transformed her into an almond tree, but its branches remained bare. Eventually Demophoön returned to Thrace and upon seeing the tree, he embraced it as if it were still a woman. At his touch the branches blossomed, and Phyllis appeared to forgive his neglect. Edward Burne-Jones first interpreted the tragedy in the watercolor *Phyllis and Demophoön* in 1870. His source was Ovid's *Heroides*, and he included a Latin inscription on the verso of the painting: "Tell me what have I done, except to love unwisely." The painting raised a scandal. Critics found the subject of a "love chase" in which the woman was the aggressor distasteful, and patrons took offense at Demophoön's nudity. But it was also widely known that the artist had a tempestuous affair with the sculptor Mary Zambaco, the model for Phyllis, and the words on the painting were rumored to be the painter's own. When asked to retouch the painting, Burne-Jones resigned from the Society and removed his work from the gallery.

A decade later, he painted *The Tree of Forgiveness*, and unveiled the work at the Grosvenor Gallery Exhibition in 1882. Although most critics still regarded the subject as "unnatural," the artist received almost universal praise for his treatment of the flowers. Along with the almond blossoms—a traditional symbol of hope—Burne-Jones scattered blue periwinkles, known in Italian as *fiore de morte* [flower of death], on the ground near Demophoön's feet. Since ancient times, pink and white periwinkles were prized as an aphrodisiac, but in medieval England the deep blue flower decorated children's caskets and was woven into garlands to crown prisoners condemned to death.

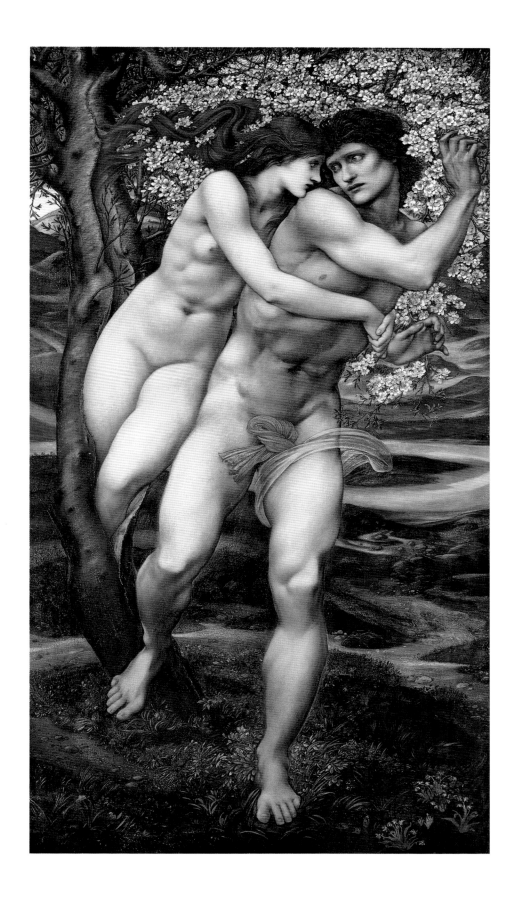

Hylas and the Nymphs 1896

John William Waterhouse (1849–1917)
Manchester City Gallery

The blossom of the *Nymphaea alba*, the native European water lily, has white, waxy petals that blush to pink near the base of the cup. The broad buoyant leaves have a glossy green surface, with an underside that is tinged with deep red. The name *Nymphaea* connects the water lily with the female spirits of classical mythology. A minor class of deities, nymphs resided in the woods, the mountains, and the waters, in the form of enticing young women who attended the goddesses and carried out their bidding. Hylas was the son of Theiodamas, the King of Dryopes, and he became Hercules's page after the hero killed his father in a conflict over cattle. Hercules developed a protective fondness for the youth, and together they sailed with Jason and the Argonauts in search of the Golden Fleece. During a brief stop on the island of Cios, Hylas sought to quench his thirst at a pond. Aroused by his adolescent beauty, the water nymphs begged him to join them, and when he refused, they dragged him below the surface of the pond. Alarmed at hearing Hylas's cries, Hercules searched for the boy, but to no avail. Hercules never found his young companion, and the Argos sailed on without them.

The nymphs in John William Waterhouse's painting of the seduction of Hylas, appear to be water lilies in human form. With their alabaster skin, tinged with the slightest blush of arousal, and their streaming auburn hair, they emerge from the water's depths in a random circle, floating like the lilies on the opaque surface of the pond. In Christian tradition, the water lily represented unsullied purity, but in the later nineteenth century, the stagnant water that nurtured the blossoms gave the symbol a sinister dimension. Like sirens and mermaids, who entranced men to make them their captives and victims, the water nymphs embodied the male horror of female sexuality; their innocent beauty disguised their insatiable desire to plunge hapless men into their foul domain.

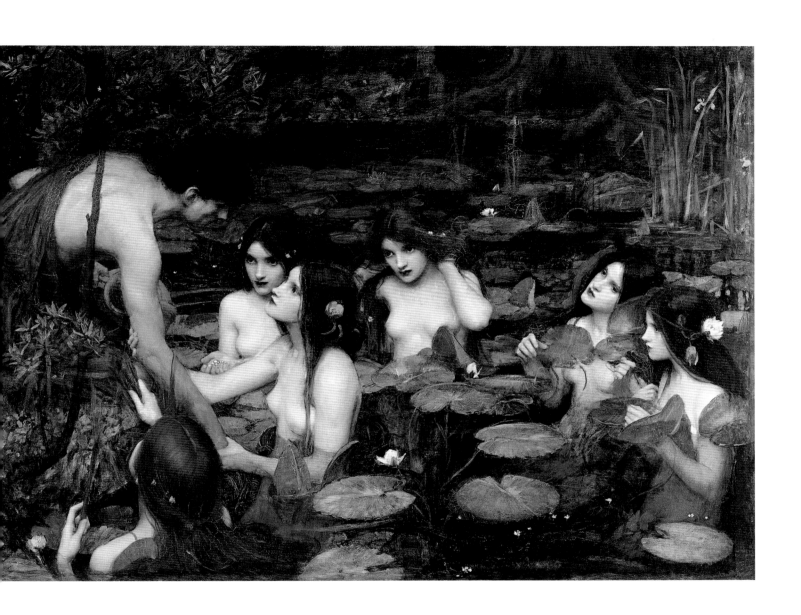

Beata Beatrix c. 1864–70

Dante Gabriel Rossetti (1828–82)
Tate Gallery, London

In February 1862, Elizabeth Siddal died of an overdose of laudanum. She had been married to Dante Gabriel Rossetti for less than two years, although she had been his muse and fiancée for more than a decade. After a year of marriage, Siddal delivered a still-born child, and the tragedy darkened her melancholy temperament into depression. Her long-standing dependency on laudanum—a tincture of opium commonly used to relieve pain and insomnia—deepened, and in the year before her death friends often commented upon her anxious behavior. Whether intentional or inadvertent, Siddal's death overwhelmed Rossetti with grief and guilt, and at her funeral, he placed the only manuscript of his poetry inside her coffin, confessing "I have often been writing at those poems when Lizzie was ill … and now they shall go." Early in the following year, Rossetti began to paint a tribute to Siddal, based on sketches he had made of her when she was alive. *Beata Beatrix*, or the Blessed Beatrice, cast her in Dante's thirteenth-century reverie *La Vita Nuova* as the desired but doomed ideal of unattainable love.

Rossetti explained in a letter that he portrayed Beatrice in a state of "sudden spiritual transformation." In the distance Dante watches helplessly as she envisions her own death, but Love beckons him on. A red dove, described by Rossetti as "a messenger of death," drops a white poppy into Beatrice's outstretched hands. Long a symbol of sleep and oblivion, the opium poppy was the source for laudanum. In his *Georgics*, Virgil—who guided Dante through purgatory to the Earthly Paradise, where he was reunited with Beatrice in La *Divina Commedia*—told how a gift of poppies placated the Shades, the souls released at the time of corporeal death. As a traditional and a personal emblem, the poppy symbolized Rossetti's loss of Siddal from his life but not from his spirit. In 1872, as the target for scorn and critical attack after he published the poems he had exhumed from her coffin, Rossetti himself attempted suicide by swallowing a bottle of laudanum.

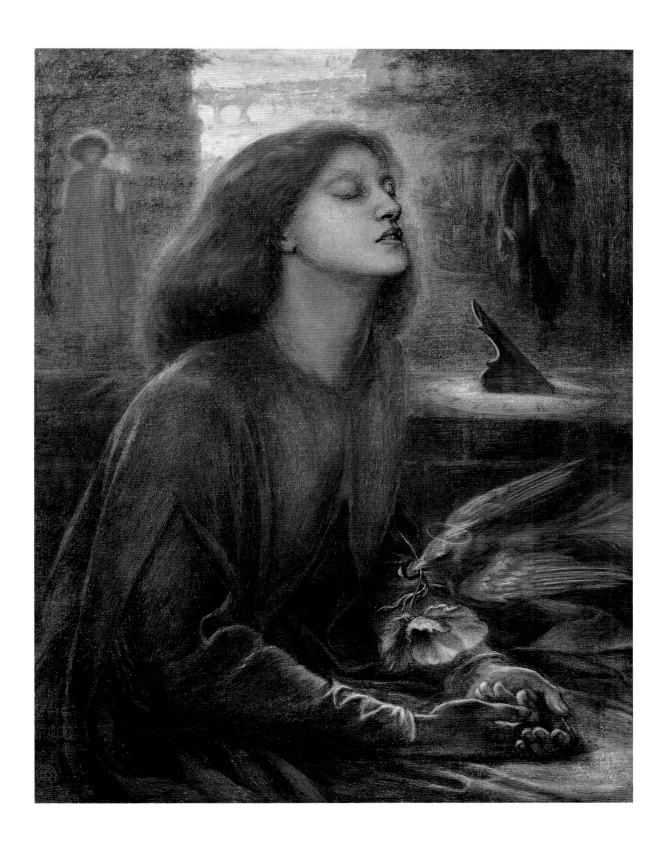

Night with Her Train of Stars c. 1912

Edward Robert Hughes (1851–1914)
Birmingham Museums and Art Gallery

In classical mythology, several deities share the poppy as their attribute. Morpheus, the god of dreams, and Hypnos, the god of sleep used the potent nectar drawn from the flower's seed to transport mortals into unconsciousness. Ceres, the goddess of the fields, wore poppies during the barren months of winter to commemorate the half-death of her daughter Persephone, who resided as Hades's bride in the Underworld for six months of every year. As an emblem of sleep and oblivion, the poppy softened the harsh finality of death, and in the Victorian era, a time of high child mortality, the metaphor of peaceful and eternal sleep gave comfort to parents as they faced the grief of losing a child.

The poignant equation of death with sleep inspired Edward Robert Hughes to personify Night as a gentle queen cradling an infant in her arms. His extended title, *Night with Her Train of Stars and her Great Gift of Sleep*, links his painting with a line from the poem *Margaritae Sorori*, written by William Ernest Henley in 1876. Hughes's Night wears a voluminous garment of midnight blue, and as her steel-grey wings propel her through the air, she is followed by crowd of *putti*, little winged infants who scatter stars in the sky. They clamor around her, reaching out to the baby in her protective embrace, but she quiets them by raising a finger to her lips. Her concern reveals that as a woman she possesses the instinct to nurture and protect, but the poppies that fall from the same hand that holds the infant reveals the true nature of her gift of slumber. In the poem *The Loves of the Plants* (1796) Erasmus Darwin refers to the poppy by its genus name *Papaver*, describing how it nods in "sullen apathy," entranced by the passing forms of "Fancy and Dreams." Derived from the Latin *pappa*, the genus name equates the thin white secretion within the flower's seed with breast milk, a fatal nourishment for the child carried by Night into eternal sleep.

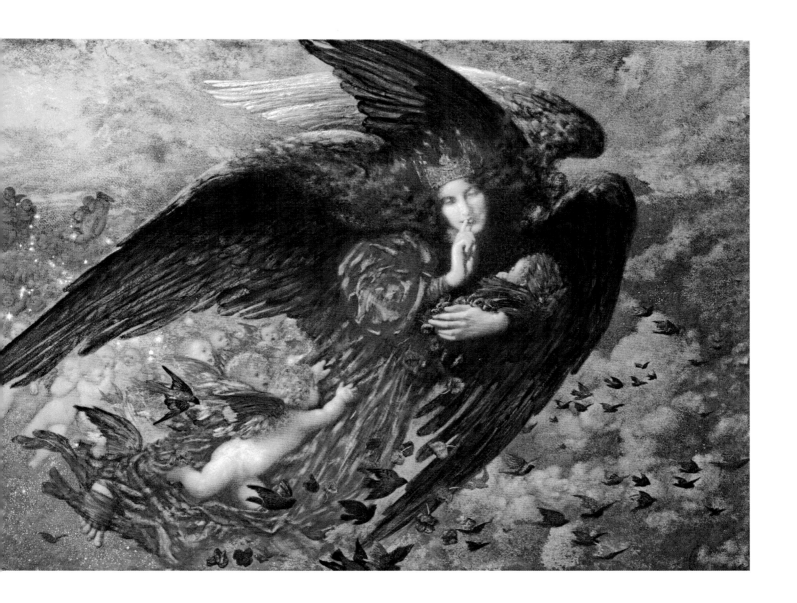

Clytie c. 1868

George Frederick Watts (1817–1904)
Watts Gallery, Compton, Surrey

I n classical mythology the heliotrope commemorates the tragic demise of the water nymph Clytie. She adored Helios, the god of the sun, but he returned her ardor with indifference. As Ovid related the tale in his poem *Metamorphosis*, it was Apollo who captivated her, but he desired another. Desperate with jealousy, Clytie sought revenge on her rival Leucothoe and betrayed her to her father, who raged against the liaison and buried his daughter alive. With Leucothoe's death, Apollo's indifference to Clytie turned to scorn, and she sank into deep despair. Day after day she sat motionless refusing to eat or sleep, watching Apollo drive his radiant chariot across the sky. Eventually the deity took pity upon her and transformed her into a heliotrope, with a sinuous stalk and a bright blossom that moved from east to west each day, following the course of the sun.

The legend endured through the centuries, but Clytie's act of vengeance disappeared from the tale, and the *Helianthus annus* or common sunflower replaced the heliotrope as the supreme symbol of submissive love. George Frederick Watts portrayed the pathos of Clytie's fate as she was subsumed into the flower that would perpetuate her passion by paying daily homage to the sun. His portrait bust personifies her eternal yearning through her agonized posture as her twisted shoulders and arched neck strain to worship the one she desired but could never possess. The sunflower represented true devotion as total surrender, just as it is celebrated in Thomas Moore's poignant poem, *Believe Me, If All Those Endearing Young Charms*: "No, the heart that has truly loved never forgets/But as truly loves on to the close;/ As the sunflower turns on her god, when he sets/The same look which she turned when he rose."

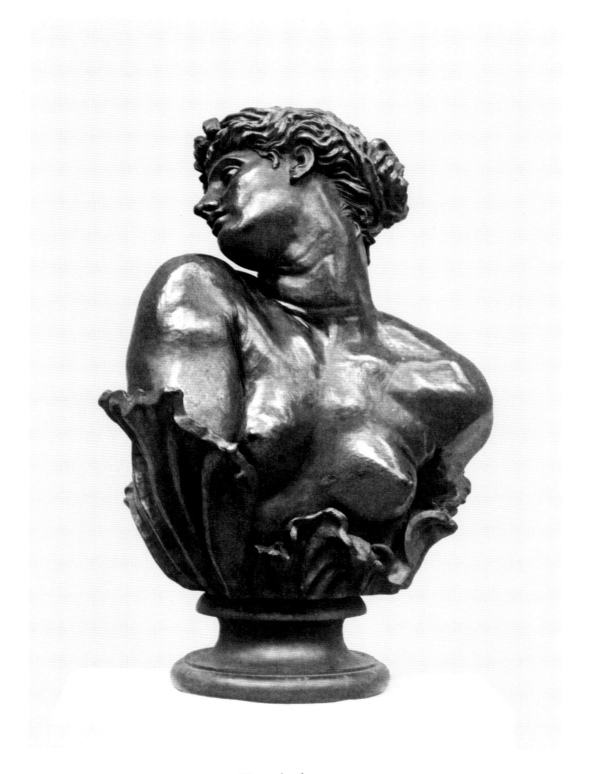

*"But such a flower never
Bloomed beneath the sun"*

Christina Rossetti

King Arthur and Sir Lancelot 1862

William Morris (1834–96)
Bradford Art Gallery

In an early prose romance, William Morris described the bright sunflowers that bloomed in a twelfth-century cloister garden. The narrator of *The Story of the Unknown Church* (1856), a stonemason who had worked at the monastery after fire destroyed the ancient chapel, marveled at the surviving courtyard with its round-arched arcade and magnificent marble fountain. On that warm autumn day, the garden was in full blossom, although it had long gone untended. Along with the sunflowers grew roses and passionflowers, traditional symbols of the Virgin's singularity and Christ's sacrifice. Morris might have been unaware that the common sunflower could not have grown in a twelfth-century European garden, but its symbolic legacy and striking appearance might also have tempted him to knowingly revise its botanical history. The Christian emblematic tradition employed the sunflower and its devotional reference to urge the pious worshiper to follow the teachings of Christ. Morris, a passionate scholar of the Middle Ages, had likely encountered late medieval emblem books that assigned such mottoes to pictorial devices. He recognized a natural heraldry in the tall flower with its dark disk surrounded by radiant petals, and, for a stained glass panel featuring King Arthur and Sir Lancelot, designed as part of an ensemble for Walter Dunlop's house, Harden Grange in Yorkshire, Morris chose the sunflower as the King's special ensign.

For his art and poetry Morris always turned to nature for inspiration. He liked his studio windows to look out upon a garden, and he favored sunflowers of the most common type, dismissing contemporary hybrids, with double blooms and unusual colors as "coarse and dull." In his design for sunflower wallpaper (1877), Morris used what he regarded as the pure form of the flower—"its sharply chiseled yellow florets relieved by the quaintly patterned sad-coloured centre"—without any reference to its emblematic meaning.

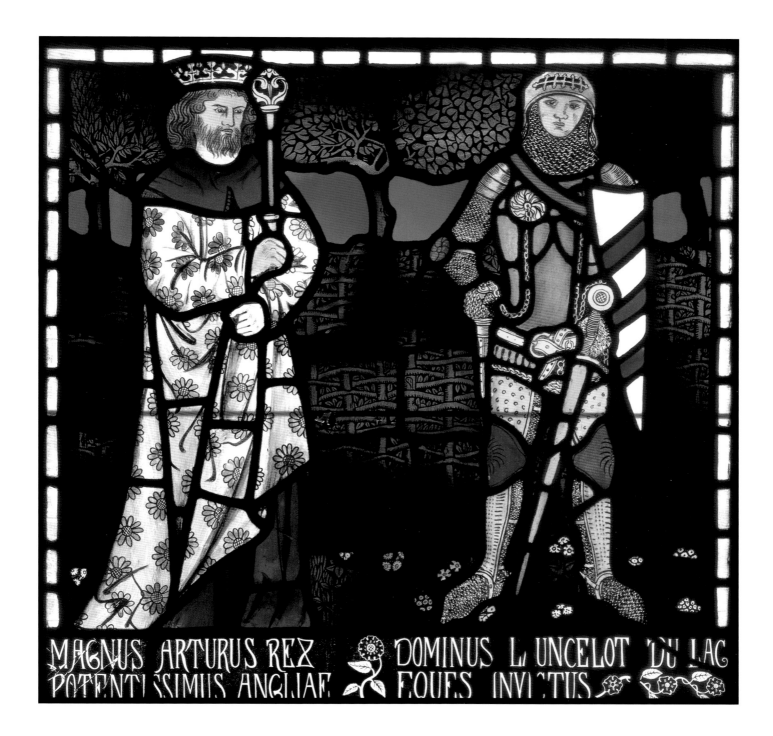

MAGNUS ARTURUS REZ DOMINUS L UNCELOT DU LAC
POTENTISSIMUS ANGLIAE EQUES INVICTUS

Scenes From the Legend of St. Frideswide

1859 (retouched c. 1890)

Edward Burne-Jones (1833–98)
Cheltenham Ladies' College

According to a twelfth-century legend, Frideswide, the daughter of the Saxon King Didan of Oxford, took a vow of chastity and lived a life of quiet contemplation within the walls of a convent. When Algar, King of Leicester, tried to force her into marriage, she fled and hid from her suitor's soldiers in a pigsty. Through divine intervention, Algar was blinded, and when he renounced his desire for Frideswide, she miraculously restored his sight. In a design for a set of windows for the Latin Chapel of Christ Church in Oxford, Edward Burne-Jones narrated the saint's life in eight separate lights. As seen in this cartoon for the fifth light, Burne-Jones added a fanciful touch, hiding her lowly refuge with the pigs behind a stand of sunflowers. Like his friend William Morris, Burne-Jones transported the common sunflower to the Middle Ages. Its strong, simple shape—as clear as a knight's device on a pennant—suited his romantic subjects, and he used a field of sunflowers again in 1861, in a drawing inspired by Robert Browning's chivalric poem *Childe Roland* (1855).

The enduring practice of pairing the sunflower with moralistic mottoes delighted Burne-Jones. In a letter to Frances Horner he asserted that it was "right to make them talk mottoes," for with their clever "faces"—sometimes brazen and at other times shy—"they all look as if they were thinking." He found eloquence—as well as moral instruction—in their traditional meanings such as "*absente sole languesco*" [in the absence of the sun I perish] and "*usque ad reditum*" [until your return], and he liked to imagine their blossoms turning to the sun with these proclamations. But he also admired the elemental aesthetic of their radiant form, musing that as a model the sunflower was "a whole school of drawing and an education in itself."

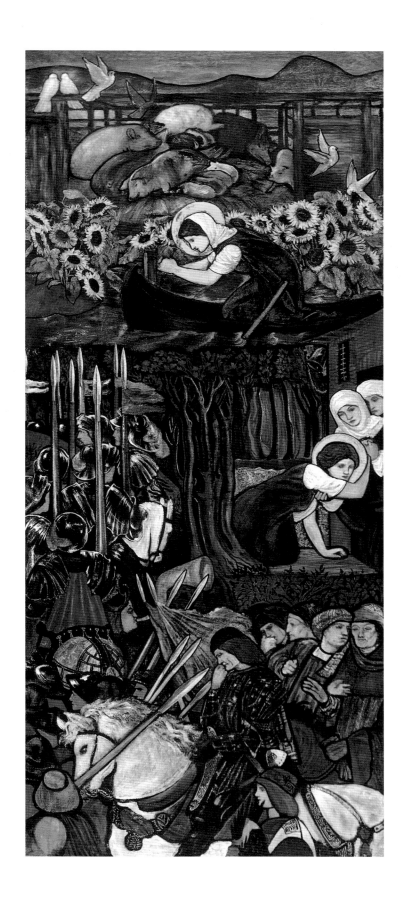

Stained Glass with Sunflowers c. 1886

Selwyn Image (1849–1930)
Victoria and Albert Museum, London

The English Arts and Crafts Movement—a self-conscious revival of craft traditions intended to reverse the falling standards of manufactured goods—had its roots in the Pre-Raphaelite circle. In 1859 William Morris and his wife Jane moved into the Red House in Bexleyheath, the new home Morris had commissioned from his friend the architect Philip Webb. To furnish and decorate their home, the Morrises recruited all their friends to paint murals on the walls and create designs for furniture, stained glass, tapestries, and tiles that could be fabricated by local craftsmen. The success of their joint efforts led Morris to found "The Firm," an artists' collaborative officially called "Morris, Marshall, Faulkner, and Company, Fine Art Workmen in Painting, Carving, Furniture, and the Metals." The business grew, and in 1875, Morris bought out his partners and continued the venture under the name Morris and Company. Tradition and nature were the touchstones of The Firm's distinctive aesthetic, and, in a lecture, *The Beauty of Life* (1880), Morris decreed: "Have nothing in your houses which you do not know to be useful or believe to be beautiful."

The Century Guild Workshops, founded in 1883 by Arthur Mackmurdo and Selwyn Image, produced designs for the home that reflected Morris's philosophy. Image, who had studied drawing with Ruskin, was the Guild's main designer, and this stained glass panel, created for the night nurseries at Pownall Hall, Cheshire, is attributed to him. Seen against a dense background of foliage, reminiscent of a tapestry verdure panel, the bright double sunflowers display an inherent ornamental quality that bridges the gulf between nature and art. Framed by a blue mosaic pattern and graced by lively doves, the panel affirms the Century Guild's objective "to render all branches of art the sphere no longer of the tradesman but the artist."

Sunflowers and Hollyhocks 1889

Kate Hayllar (fl. 1883–98)
Guildhall Art Gallery, London

The credo "Art for Art's Sake," inspired the Aesthetic Movement and, for a brief time, an artistic approach to interior and fashion design became the hallmark of advanced taste. Like the Arts and Crafts Movement, the Aesthetic Movement stood in opposition to the growing popularity of inexpensive manufactured goods for the home, dismissing them as inferior in quality and design. But while the Arts and Crafts Movement struck an alliance between beauty and utility, the Aesthetic Movement asserted that the beauty of an object in and of itself was sufficient justification for its production and its display. Devotees of the Aesthetic Movement valued rarity over practicality, and the Aesthetic interior often boasted an eclectic mix of furniture and decorative objects drawn from all corners of the world and every period in history. Kate Hayllar, a still-life painter, portrayed a sumptuous aesthetic interior in the painting *Sunflowers and Hollyhocks*. This corner of an "artistic" drawing room features an eccentric display: antique furniture, an Indian shawl, a Turkish rug, Chinese urns, and a Japanese screen. Among these treasures are bright hollyhocks and giant sunflowers, common to English gardens but also prized by aesthetes for their inherent beauty as nature's ornament.

Victorian florigraphy assigned conflicting meanings to these flowers. Hollyhocks signified both ambition and fecundity, while the sunflower's traditional message of constancy was overshadowed by less appealing references to haughtiness and false riches. But as the symbol of aesthetic taste, the sunflower shed all cultural significance and conventional iconography. By the early 1880s, the sunflower was so strongly associated with aesthetic taste, Mary Eliza Haweiss, author of the column "Beautiful Houses" in the women's journal *The Queen*, remarked acidly that "a blue pot and a fat sunflower … are all that is needed to be fashionably aesthetic."

Caricature of Oscar Wilde as a Sunflower 1881

Edward Linley Sambourne (1844–1910)
Punch Magazine, London

Oscar Wilde first gained recognition through his prize-winning performance as a literature scholar at Trinity College, Dublin and at Oxford University. Shortly after he moved to London in 1879, he demonstrated a powerful talent for self-promotion and established a reputation for charming conversation and a rapier-sharp wit. His unorthodox manner of dress–custom-made, form-fitting velvet jackets in rich tones of forest green and garnet red, as well as his flowing hair and imposing physique–made him the focus of attention whenever he appeared at the theater or in art galleries. As an outspoken advocate of aestheticism, Wilde presented himself as a walking spectacle, an eye-catching testament to a life dedicated to the arts. But the long-awaited publication of his first collection of poems in 1881 met with disappointment. Conventional and classical, the poetry paled next to his outlandish public image, and the reviewers pointed out that Wilde was more show than substance. In the humorous journal *Punch* Edward Linley Sambourne quipped "The poet is WILDE, / But his poetry's tame," and caricatured Wilde as a sunflower.

Wilde himself preferred the lily as his signature emblem. But by the time he embarked on his tour of North America, the sunflower was the favored icon for his larger-than-life presence as well as for the Aesthetic Movement, which was the topic of his lectures. The comic press depicted him holding a huge sunflower while engaging in "American" activities, such as buying western boots and wielding a tomahawk. After a disruptive gang of Harvard students, dressed in velvet knickerbockers and carrying sunflowers, heckled him in Boston, Wilde felt compelled to defend the floral symbol that had been forced upon him. In his *Lecture on the English Renaissance* (1882), he explained that English artists regarded the sunflower and the lily as the "most perfect models of design," the lily representing "precious loveliness" and the sunflower being renowned for its "gaudy leonine beauty."

OSCAR WILDE.

" O, I feel just as happy as a bright Sunflower ! "
Lays of Christy Minstrelsy.

Æsthete of Æsthetes !
What 's in a name ?
The poet is WILDE,
But his poetry 's tame.

Dame (Alice) Ellen Terry ("Choosing")

c. 1864

George Frederick Watts (1817–1904)
National Portrait Gallery, London

When Ellen Terry met George Frederick Watts she was only fifteen, but she already had earned wide recognition for her work on the stage. Born into a theatrical family, Terry debuted at age nine as Mamillus in Charles King's production of A *Winter's Tale* and since then had played a variety of popular roles. Infatuated with the coltish Terry, Watts vowed to extricate her from "the temptations and abominations of the stage."

Despite the difference in their ages, Watts and Terry wed in February 1864. As well as his wife, she became his model, taking on as wide a repertoire of roles—from youthful knights such as Sir Galahad to tragic young heroines such as Ophelia—as she had played as an actress. For *Choosing*, Terry appeared as Watts saw her, a winsome girl on the brink of womanhood.

Dressed in a modest gray gown, Terry seems even younger than her years. Her pale, red hair tumbles to her shoulders, and her string of pearls—a symbol of preciousness and purity—offers an appropriate tribute to her tender state of emotional vulnerability. The violets she cups in her left hand signify her sweet innocence, but she is distracted by the spectacular red camellias that surround her. Her attempts to enjoy their fragrance are futile; noted for beauty, the camellia has no scent. As one of the most fashionable—as well as expensive—flowers of its day, the camellia was a popular ornament, and the well-known play presenting of a famous courtesan, *La Dame aux camelias* (1848) by Alexandre Dumas fils, had given "the rose of Japan" a theatrical association, as well as a dubious reputation. In *Choosing*, Watts situated Terry between what he regarded as the false attractions of the stage and the true rewards of matrimonial devotion. But Terry soon made her own choice: after barely a year of marriage to the older painter, she left him to resume her theatrical career.

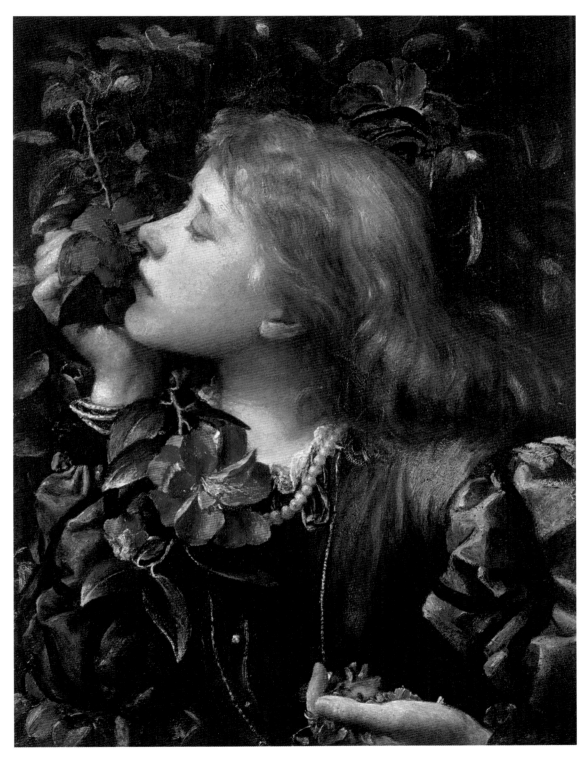

"Young maids may wonder if the flowers
Or meanings be the sweeter"

Elizabeth Barrett Browning, *A Flower in a Letter*

Portrait of Georgiana Burne-Jones 1870

Edward Burne-Jones (1833–98)
Private Collection

Georgiana Burne-Jones (née Macdonald) recalled that she was only a "child in a pinafore" when she met her future husband. As a school friend of her older brother Harry, young Edward Jones (who added the maternal name Burne to his surname in the late 1850s) made regular visits to the Macdonald household, even when Harry was not at home. In 1856, Jones proposed to sixteen-year-old "Georgie," and they married four years later. In her, Burne-Jones found more of a mate than a muse. Plain and practical, Georgie possessed an abundance of good sense, sharp intelligence, and a loyal nature. She supported her husband through financial difficulties, critical disparagement, illness, and recurrent depression, as well as pain and embarrassment brought on by his scandalous liaison with Mary Zambaco. In the wake of their marital crisis, she had no words of recrimination for her husband, and later she reflected that "beauty and misfortune" held her husband in its sway, and that "far he would go to serve either."

Burne-Jones began this portrait of his wife in 1883, and although he worked on it over the years, he never regarded it as finished. He presents his wife in the same compositional format that he used for Zambaco's birthday portrait: a half-length figure in a confined space, leaning on a ledge with her gaze directed out to the viewer. But, in contrast to Zambaco's nervous yearning, Georgie is serene. In a distant room, the Burne-Jones children represent the domestic balance of the household: Philip paints as Margaret stands by to encourage him. For Georgie's attributes, Burne-Jones chose an antique botanical and a heartsease pansy. As a symbol of kind concern, the pansy celebrates Georgie's wifely devotion, but the book recalls an older tradition. Early herbals emphasized the curative powers of plants, and the pansy was recommended to soothe painful disorders of the heart. Both an anodyne and an emblem of selfless love, the heartsease became for Burne-Jones a tribute to his wife's boundless sacrifice and understanding, and when he died of pulmonary failure, Georgie placed a bouquet of pansies on his grave.

Study for "Water Willow" 1871

Dante Gabriel Rossetti (1828–82)
Birmingham Museums and Art Gallery

Dante Gabriel Rossetti once described Kelmscott Manor as the "loveliest haunt of ancient peace." In the spring of 1871, William Morris had searched for a summer retreat for his wife Jane and their daughters, and when he discovered an Elizabethan stone house with an old-fashioned garden in Oxford-shire on the upper reaches of the Thames, he and Rossetti leased it together. Morris settled his family and his friend into the picturesque manor early in July and then departed for Iceland to fulfill a long-held dream of visiting the birth-place of the Norse sagas. Sharing a modest-sized household with Jenny and May Morris, as well as several servants, did not give Rossetti much opportunity to be completely alone with Jane, but over the summer they enjoyed the companion-able privacy, away from the judgmental gossip that surrounded them in London. In tribute to their time together Rossetti posed Jane on the manor's grounds with the river winding behind her. In the final version of the portrait, Jane holds several branches of water willow, a symbol for frankness, but in a chalk study her attribute is a heartsease pansy.

The simple pansy was Jane's favorite flower. Rossetti once designed stationery for her, featuring the tri-colored blossom in purple and gold, but Jane found it too ornate. Years later, Wilfred Scawen Blunt claimed that, when he was Jane's lover, she indicated her desire by leaving a single pansy on his bed. Always dis-creet, Jane made no mention of this ritual, and she always maintained that she and Rossetti were no more than close friends, although she did acknowledge that their relationship was "very warm while it lasted." As the traditional emblem of caring friendship, the heartsease pansy embodied the idyllic summer she and Rossetti shared in Kelmscott Manor. Perhaps the pansy had an intimate meaning as well. While the exact reference of the pansy can only be speculative, Rossetti did confess to his brother William that he painted to portrait to embody "the penetrating sweetness of the scene and the season."

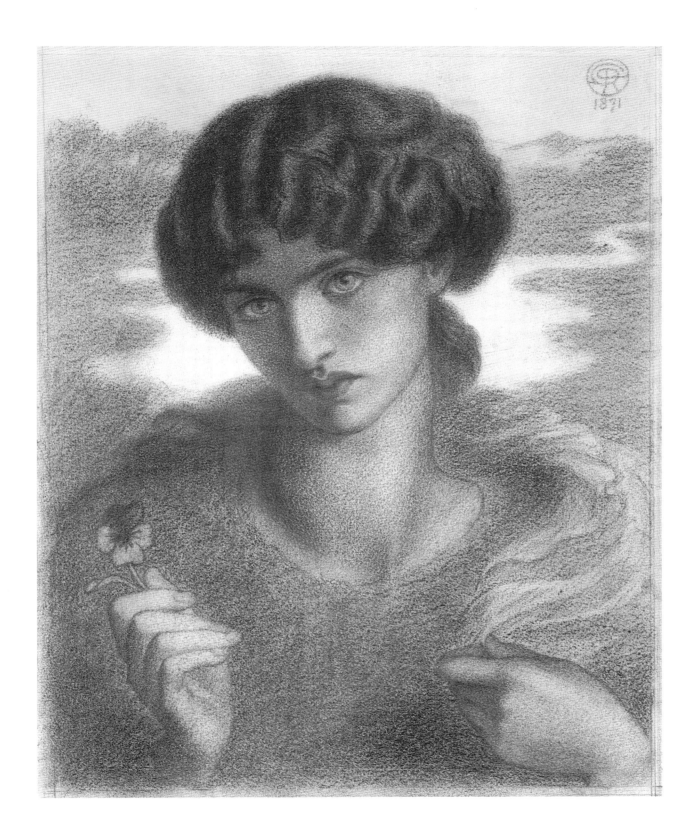

Mrs. Jane Morris (The Blue Silk Dress) 1868

Dante Gabriel Rossetti (1828–82)
Kelmscott Manor, Kelmscott, Gloucestershire

In 1866 William Morris asked his friend Dante Gabriel Rossetti to paint a portrait of his wife Jane. To prepare for the commission, Rossetti made countless sketches of her, refining his mastery of her distinctive physical characteristics–her tightly crimped hair, her languid grace, her brooding eyes, and the lithe length of her hands and neck–and after two years of intense concentration on his singular subject, Rossetti informed Jane that he was ready to begin. For the first sitting, Rossetti invited Morris to join them, but as the work progressed, Jane went to the studio alone. The pensive portrait features Jane in a simple but lustrous blue silk gown that enhances the her pale luminous skin, and as she restlessly clasps her long tapered hands her wedding ring is clearly evident. Rossetti crowned the work with a Latin inscription: *Jane Morris A. D. 1868 D. G. Rossetti pinxit. Conjuge clara poetâ, et praeclarissima vultu, Denique picturâ clara sit illa meâ!* [Famous for her poet husband, and famous for her face, may my picture add to her fame].

The open book reveals that Jane had been reading. She lifts her head to gaze upon the person who has entered her private domain. The air of intimacy in the dark room–as well as her wedding ring–suggests that it is Morris who has interrupted her. But the flowers Rossetti chose for the portrait hint at a hidden message. Since the Middle Ages in England, carnations, along with pinks, and gillyflowers, signified a woman's pure love, while white roses announced, "I am worthy of you." While painting Jane's likeness, Rossetti was also composing the poetic cycle *The House of Life*, and the tenth sonnet, entitled "The Portrait" concludes with the line "They that would look upon her must come to me." These words leave no doubt as to whom the floral message is directed: deeply in love with Jane, Rossetti used his art to proclaim his ardent desire.

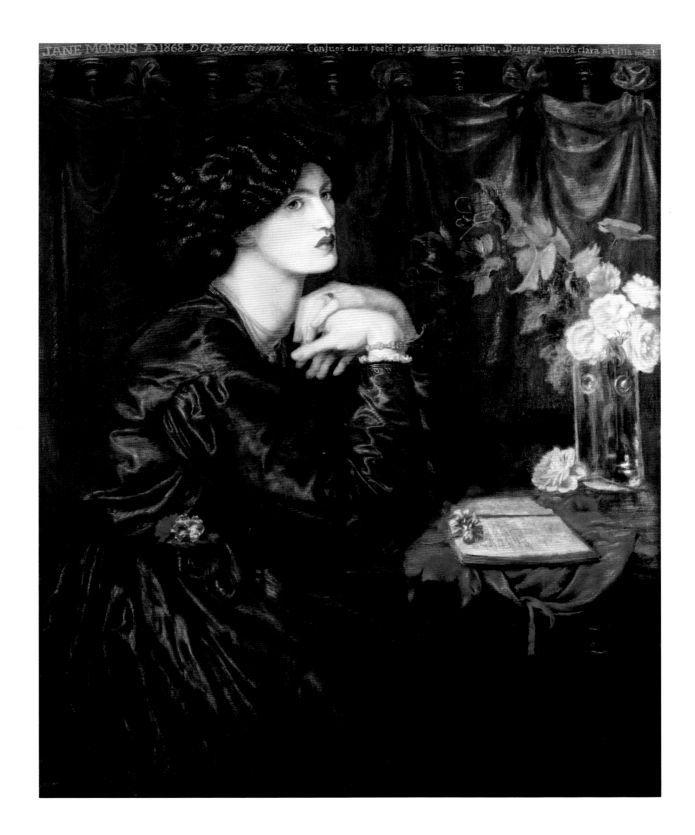

Lillie Langtry 1878

Edward Poynter (1836–1919)
Jersey Museum, St. Helier, Jersey

Lillie Langtry burst on the London social scene in May 1876. As she made the rounds of dinners and parties her striking good looks earned her celebrity as a "professional beauty." Tall and curvaceous, Langtry had the firm profile and dignified presence of an antique statue come to life. Her high, clear complexion–as well as her birthplace on the isle of Jersey–won her the nickname "The Jersey Lily," and within a few months of her social debut, every important artist in London was competing for the opportunity to paint her. Frank Miles earned his living making pencil sketches of celebrities which he sold to publishers for postcards and prints. It is likely that while Langtry was sitting to Miles she first encountered Oscar Wilde. Miles and Wilde had long been friends and, in 1879, when Wilde left Oxford for London, he rented a flat in Thames House on Salisbury Street where Miles had his studio. Together they planned to promote Langtry's fame, Miles with his pencil and Wilde with his pen.

The art critic H. C. Marillier recalled that as a schoolboy he had seen Edward Poynter's portrait of Langtry displayed on an easel surrounded by lilies in Wilde's drawing room. Wilde had adopted the lily as his personal emblem, but it was Miles who grew them–his botanical interests even led to the cultivation of a new species. The pots of lilies and the painted white walls in Wilde's flat complemented the tonal subtlety of Poynter's portrait of Langtry in a tight gold dress trimmed with ribbons, lace, and roses in varying shades of white. Surprisingly, her signature lily is absent; instead she holds white roses. Perhaps Wilde, who once declared, "I would have rather discovered Mrs. Langtry than have discovered America," knew that the roses bore a traditional message: "I am worthy of you." But his offering of lilies transformed the portrait into an altar to her beauty, and, in taking on the role of devoted acolyte, it was Wilde who dared to suggest that he was worthy of her.

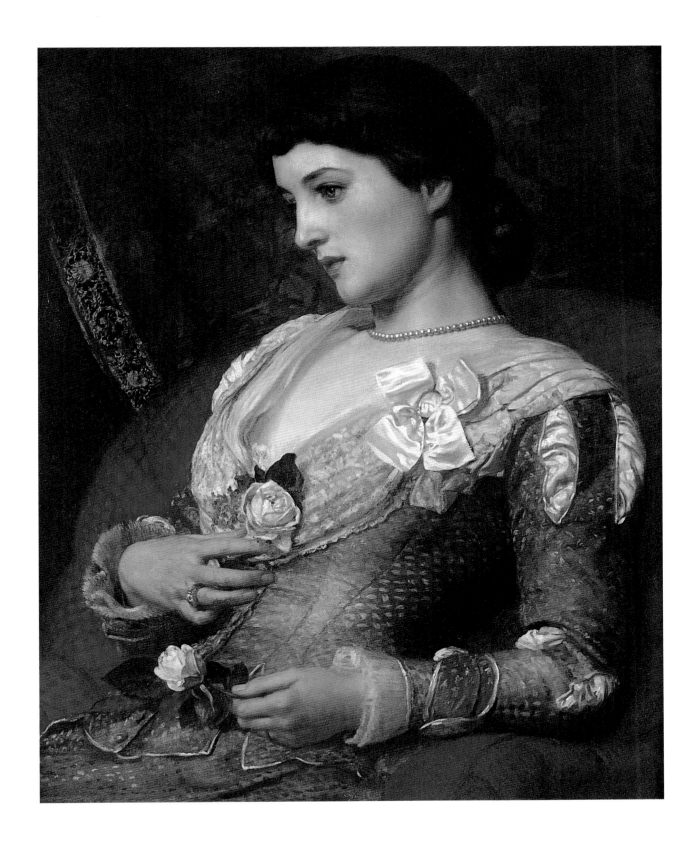

Portrait of Mary Zambaco 1870

Edward Burne-Jones (1833–98)
Clemens-Sels-Museum, Neuss, Germany

Mary Zambaco accompanied her mother, Euphrosyne Cassavetti, to Edward Burne-Jones's studio in 1866. A sophisticated widow, Cassavetti was a member of the Ionides family who formed a cosmopolitan Greek enclave in London. She proposed that her daughter pose for a watercolor of Cupid finding Psyche and later requested a reduced replica of Burne-Jones's painting *Chant d'Amour* (1868). With aquiline features, startlingly white skin, and abundant mahogany-red hair, Zambaco made a stunning model for mythological heroines, but she was also artistically gifted and an affluent and independent divorcée. Over the next two years Zambaco was a constant presence in Burne-Jones's studio. But their private liaison became a public embarrassment in January 1869, when Burne-Jones refused to leave his family to move with her to Thessaly. She attempted to drown herself–as well as Burne-Jones–in the Regent's Canal, and the police were called to break up the disturbance. The scandal revived later that spring when visitors to the Old Water-Colour Society saw Zambaco as Phyllis reaching out of an almond tree to clasp Demophoön in a desperate embrace (see pp. 56–57). Although Burne-Jones vowed to end the relationship, sketches reveal that Zambaco continued to haunt him, and in 1870, on the occasion of her birthday, her mother commissioned him to paint her portrait. The attributes he used to celebrate her beauty also lament the failure of their romance. As a wary figure of Cupid draws away a heavy drape, Zambaco fixes her mournful gaze upon the viewer. A slip of paper, wrapped around an arrow, records her birthday and his signature: "*Mary Aetat XXVI August 7th 1870 EBJ pinxit.*" The manuscript is illuminated with a version of *Chant d'Amour,* one of the paintings that brought them together. But the blue irises proclaim sorrow heralded in their alliance, and in Zambaco's hand is a sprig of white dittany, an emblem of passion commonly known as "dittany of Crete."

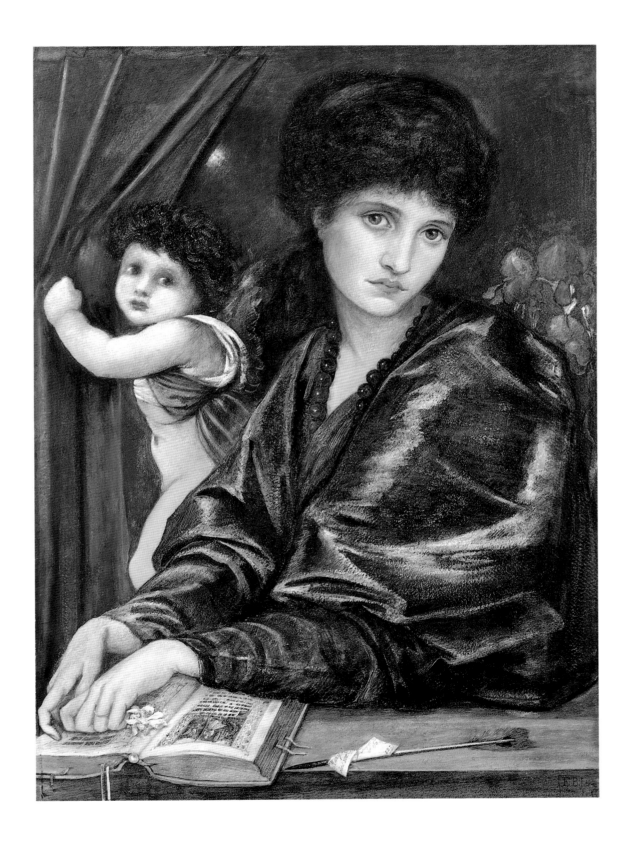

List of Illustrations

Franz Xaver Winterhalter (1805–73),
Queen Victoria with Prince Arthur, 1850.
Oil on canvas, 59.5 x 71.5 cm.
The Royal Collection © 2003,
Her Majesty Queen Elizabeth II.

Charles Allston Collins (1828–73),
Convent Thoughts, 1851.
Oil on canvas, 84 x 59 cm.
Ashmolean Museum, Oxford.

William Dyce (1806–64),
*Titian Preparing to Make His First Essay in
Colouring*, 1857.
Oil on canvas, 100.5 x 79 cm.
© Aberdeen Art Gallery and Museum.

Philip Hermogenes Calderon (1833–98),
Broken Vows, 1856.
Oil on canvas, 91.4 x 67.9 cm.
© Tate, London 2003.

John Everett Millais (1829–96),
Ophelia, 1851–52.
Oil on canvas, 76.2 x 111.8 cm.
© Tate, London 2003.

John William Waterhouse (1849–1917),
Ophelia, 1894.
Oil on canvas, 124.4 x 73.6 cm.
© Schaeffer Collection, Australia. Photo: David Brown.

Arthur Hughes (1832–1915),
The Letter: Portrait of a Girl in a Violet Dress, c. 1860.
Oil on canvas, 38 x 29 cm.
Ashmolean Museum, Oxford.

Arthur Hughes (1832–1915),
Forget Me Not, 1901–02.
Oil on canvas, 106 x 63 cm.
© Christie's Images, Limited, 2003.

John Everett Millais (1829–96),
The Bridesmaid, 1851.
Oil on panel, 27.9 x 20.3 cm.
Reproduction by permission of the Syndics of the
Fitzwilliam Museum, Cambridge.

John Everett Millais (1829–96),
Spring (Apple Blossoms), 1859.
Oil on canvas, 113 x 176.3 cm.
Board of Trustees of the National Museums and Galleries on
Merseyside (Lady Lever Art Gallery, Port Sunlight).

Dante Gabriel Rossetti (1828–82),
The Girlhood of Mary Virgin (1848–49).
Oil on canvas, 83.2 x 65.4 cm.
© Tate, London 2003.

Dante Gabriel Rossetti (1828–82),
Ecce Ancilla Domini, 1849–50.
Oil on canvas, 72.4 x 41.9 cm.
© Tate, London 2003.

Arthur Hughes (1832–1915),
The Annunciation, 1857–58.
Oil on canvas, 61.3 x 35.9 cm.
Birmingham Museums and Art Gallery.

Dante Gabriel Rossetti (1828–82),
The Blessed Damozel, 1875–78.
Oil on canvas, 136.84 x 96.52 cm.
Courtesy of the Fogg Art Museum, Harvard University Art
Museums, Bequest of Grenville L. Winthrop.
Photo: Katya Kallsen, © President and Fellows of Harvard
College.

Sophie Anderson (1823–1903),
Elaine, 1870.
Oil on canvas, 158.4 x 240.7 cm.
Board of Trustees of the National Museums and
Galleries on Merseyside (Walker Art Gallery, Liverpool).

Dante Gabriel Rossetti (1828–82),
The Beloved (The Bride), 1865–66.
Oil on canvas, 82.5 x 76.2 cm.
© Tate, London 2003.

Dante Gabriel Rossetti (1828–82),
La Ghirlandata, 1871–74.
Oil on canvas, 115.6 x 87.6 cm.
Guildhall Art Gallery, Corporation of London, UK/
Bridgeman Art Library.

Dante Gabriel Rossetti (1828–82),
The Roseleaf, 1870.
Two types of graphite on woven paper,
39 x 35.2 cm.
Photograph © National Gallery of Canada, Ottawa.

Edward Burne-Jones (1833–98),
The Rose Bower from *The Briar Rose Series*, 1884–85.
Oil on canvas, 125 x 228.6 cm.
The Faringdon Collection, Buscot Park, Oxfordshire,
England.

Edward Burne-Jones (1833–98),
Heart of the Rose, 1891.
Roy Miles Fine Paintings/Bridgeman Art Library.

John William Waterhouse (1849–1917),
The Soul of the Rose, 1908.
© PreRaphaelite Inc. by courtesy of Julian Hartnoll.

Dante Gabriel Rossetti (1828–82),
Venus Verticordia, 1864–68.
Oil on canvas, 82 x 69 cm.
Russell-Cotes Art Gallery and Museum, Bournemouth, UK/
Bridgeman Art Library. Supported by the National Art Col-
lections Fund.

Frederick Sandys (1829–1904),
Vivien, 1863.
Oil on canvas, 64 x 52.5 cm.
© Manchester Art Gallery.

Edward Burne-Jones (1833–98),
The Tree of Forgiveness, 1881–82.
Oil on canvas, 196 x 106.8 cm.
Board of Trustees of the National Museums and Galleries on Merseyside (Lady Lever Art Gallery, Port Sunlight).

John William Waterhouse (1849–1917),
Hylas and the Nymphs, 1896.
Oil on canvas, 98.2 x 163.3 cm.
© Manchester Art Gallery.

Dante Gabriel Rossetti (1828–82),
Beata Beatrix, c. 1864–70.
Oil on canvas, 86.4 x 66 cm.
© Tate, London 2003.

Edward Robert Hughes (1851–1914),
Night with Her Train of Stars, c. 1912.
Watercolor and bodycolor and gold paint on paper, 7.55 x 12.45 cm.
Birmingham Museums and Art Gallery.

George Frederick Watts (1817–1904),
Clytie, c. 1868. Bronze.
Trustees of the Watts Gallery, Compton, Surrey, UK/ Bridgeman Art Library.

William Morris (1834–96),
King Arthur and Sir Lancelot, 1862.
Stained glass window, designed by William Morris and executed by William Morris and Co.
Bradford Art Galleries and Museums, West Yorkshire, UK/ Bridgeman Art Library.

Edward Burne-Jones (1833–98),
Scenes From the Legend of St. Frideswide, 1859; retouched c. 1890.
Oil on canvas, 183 x 76.2 cm.
Cheltenham Ladies' College.

Selwyn Image (1849–1930),
Stained Glass with Sunflowers, c. 1886.
Three panels, stained and painted glass, 49.4 x 100.2 cm.
V&A Picture Library, London.

Kate Hayllar (fl.1883–98),
Sunflowers and Hollyhocks, 1889.
Watercolor on paper, 31.75 x 24.13 cm.
Guildhall Art Gallery, Corporation of London, UK/ Bridgeman Art Library.

Edward Linley Sambourne (1844–1910), *Caricature of Oscar Wilde as a Sunflower*, 1881.
Punch magazine.
McCormick Library of Special Collections, Northwestern University.

George Frederick Watts (1817–1904),
Dame (Alice) Ellen Terry ("Choosing"), c. 1864.
Oil on strawboard mounted on Gatorfoam, 47.2 x 35.4 cm.
By courtesy of the National Portrait Gallery, London.

Edward Burne-Jones (1833–98),
Portrait of Georgiana Burne-Jones, 1870.
Oil on canvas, 77.47 x 54.61 cm.
Private collection.

Dante Gabriel Rossetti (1828–82),
Study for "Water Willow", 1871.
Colored chalks on pale green paper,
34 x 27.2 cm
Birmingham Museums and Art Gallery.

Dante Gabriel Rossetti (1828–82),
Mrs. Jane Morris (The Blue Silk Dress), 1868.
Oil on canvas, 138.41 x 118.1 cm.
Reproduced with the permission of The Society of
Antiquaries of London.

Edward Poynter (1836–1919),
Lillie Langtry, 1878.
Oil on canvas, 76 x 66 cm.
Courtesy of the Jersey Heritage Trust.

Edward Burne-Jones (1833–98),
Portrait of Mary Zambaco, 1870.
Gouache on card, 76.3 x 55 cm.
© Clemens-Sels-Museum, Neuss, Germany.

Frontispiece:
William Morris (1834–96),
Wallpaper sample trellis 9,
Birds by Philip Webb
Registered February 1, 1864
Printed by Jeffrey & Co. for Morris, Marshall,
Faulkner & Co.
Block printed in distemper colors, 68.6 x 50 cm.
V&A Picture Library, London.

Front and back covers:
William Morris (1834–96),
Designed 1868–70,
Block-printed by Clarkson and later Thomas Wardle
& Sons, Leek.
Repeat: 45 x 45.5 cm. Width: 91.5 cm.
V&A Picture Library, London.

Biographies

Sophie Anderson (1823–1903)

Anderson was born in Paris where she received her first art training. In 1848 she moved with her family to the United States where she married the English artist Walter Anderson in 1854. In the following year, they moved to England, and she made her reputation as a painter of sentimental anecdotes.

Edward Burne-Jones (1833–98)

Burne-Jones met William Morris while he was a theology student at Oxford University. In 1855, meeting Rossetti in London inspired him to leave school and become an artist. The three are regarded as a "second generation" of Pre-Raphaelites. Primarily a painter, Burne-Jones also created designs for all the decorative arts in collaboration with Morris and his business ventures.

Georgiana Burne-Jones, née Macdonald (1840–1920)

"Georgie" was the fifth child in the large family of the Methodist minister George Macdonald. She met Edward Burne-Jones, a schoolmate of her older brother, and they married in 1860. They had two children, Philip and Margaret. She only modeled occasionally for her husband who valued her emotional support.

Philip Hermogenes Calderon (1833–98)

Born in Poitiers, Calderon began to exhibit his work at the Royal Academy in London in 1853. *Broken Vows* (1857) reveals a strong Pre-Raphaelite influence and, in the form of an engraving, became his most popular painting. A founder of the St. John's Wood Clique, Calderon painted mostly portraits after 1870.

Charles Allston Collins (1828–73)

Collins, son of a painter and a student at the Royal Academy Schools, was a close friend of Millais, who nominated him to the Pre-Raphaelite Brotherhood. Although Collins did not join, he worked in a style that reflected their aims in art and was regarded as a Pre-Raphaelite painter by the critics.

William Dyce (1806–64)

As the leading artist in the interior decoration of the new palace at Westminster, Dyce created a British equivalent to the revivalist German Nazarene painting style in fresco. He was admired by the Pre-Raphaelite Brotherhood for his austere aesthetic and legendary subject matter, while he, in turn, was influenced by their fidelity to nature.

Kate Hayllar (fl. 1883–98)

One of the four daughters of painter James Hayllar, all of whom entered their father's profession, Hayllar exhibited her floral paintings and still lifes at the Royal Academy. In 1900 she took up nursing, which apparently ended her artistic career.

Arthur Hughes (1832–1915)

After studying at the Royal Academy Schools, Hughes discovered the ideas of the Pre-Raphaelite Brotherhood by reading *The Germ* (1850). He immediately adapted their objectives to his own work, and while he adhered to their style most closely in the 1850s, his work retained the lyrical quality that he developed in response to their influence throughout his long career.

Edward Robert Hughes (1851–1914)

Hughes trained at the Royal Academy Schools, but also was a student of his uncle Arthur Hughes and original Pre-

Raphaelite Brother William Holman Hunt. He painted landscapes and portraits but is best-remembered for his fairy and fantastic subjects as well as an evocative Symbolist aura that appeared late in his career.

Selwyn Image (1849–1930)
As a student at New College, Oxford, Image studied drawing with John Ruskin. Interested in theology and the arts, he was ordained in 1873, but left the clergy in 1882 to devote his full attention to design. He founded the Century Guild Workshops with Arthur Mackmurdo and was active in the Art Workers' Guild of London.

Lillie Langtry née *Le Breton* (1853–1929)
Langtry moved from the island of Jersey to London with her husband in 1876. A popular socialite, she reigned as a "Professional Beauty," and her image was reproduced in photographs and prints and widely collected. Admired by Wilde, she enjoyed a modest career on the stage and notoriety as the mistress of Edward, Prince of Wales.

Frank Miles (1852–91)
Miles met Wilde on a visit to Oxford in the summer of 1875. He earned his living making pencil sketches of popular socialites in his London studio. He and Wilde remained close friends and were neighbors when Wilde moved to London in 1879. Miles was also an amateur botanist who cultivated lilies.

John Everett Millais (1829–96)
A precocious child, Millias entered the Royal Academy Schools at nine. One of the founding members of the Pre-Raphaelite Brotherhood, his early works were harshly reviewed, but he was the only one of the original Brothers to be elected to the Royal

Academy. Highly successful throughout his career he was briefly President of the Royal Academy (1896).

Jane Morris, née *Burden* (1840–57)
The daughter of a working-class Oxford family, Jane Burden first posed for Rossetti in 1857. She married Morris in 1859 and they had two daughters, Jenny and May. In 1865, Rossetti's fascination with her unorthodox beauty revived, and for the rest of his life he regarded her as his favorite model, his muse, and the inspiration of his art.

William Morris (1834–96)
Born into a wealthy family, Morris studied theology at Oxford University, where he met Burne-Jones. Convinced by Rossetti to become a painter, Morris met his wife Jane in Oxford in 1857 and they married in 1859. Multi-talented, Morris is best known for his poetry, his business ventures, and his influential design work that established the principles of the British Arts and Crafts Movement.

Walter Pater (1839–94)
A noted lecturer at Brasenose College, Pater gained fame for his publication *Studies in the History of the Renaissance* (1873). He is credited with creating the English term "art for art's sake," which has been regarded as the credo of the Aesthetic Movement. As an art critic, he admired the work of Rossetti and strongly influenced Wilde's aesthetic ideas.

Edward Poynter (1836–1919)
This prominent academic painter, known for his, neoclassical history paintings, was also an accomplished portraitist. He was married to one of Georgiana Burne-Jones's sisters, and his attachment to the Pre-Raphaelites was familial and social.

Poynter served as Director of the National Gallery (1894–1906) and the President of the Royal Academy (1896–1918).

Christina Georgina Rossetti (1830–94)
The youngest sister of Dante Gabriel Rossetti, the poet Christina Rossetti enjoyed a close and collegial relationship with the Pre-Raphaelite Brotherhood. Her poetry first appeared in their journal *The Germ* (1850) under an alias. *Goblin Market and Other Poems* marked her public debut, published in 1862 with illustrations designed by her brother.

Dante Gabriel Rossetti (1828–82)
More than any of the other original Brothers, Rossetti is associated with the creation and perpetuation of Pre-Raphaelite ideals in art. Long after the original circle dispersed, Rossetti attracted younger adherents to his aesthetic. In his poetry as well as his painting, he expressed his belief in romantic love and idealized his own life, particularly his passion for his wife Siddal followed by his desire for Jane Morris, in his art.

William Michael Rossetti (1829–1919)
The younger brother of Dante Gabriel Rossetti, William Rossetti was one of the founding Pre-Raphaelite Brothers. He served as the Brotherhood's secretary and went on to an active career as an art critic, writing for various prominent journals, such as the *Spectator*, and compiling his brother's papers, with his own comments, for publication.

John Ruskin (1819–1900)
The son of a prosperous merchant, Ruskin was a brilliant student, publishing a defense of the artist J.M.W. Turner while a student at Oxford. The early books of his five-volume opus *Modern Painters* (1843–1860)–particularly his views on nature–had a profound influence on the Pre-Raphaelite Brotherhood, and Ruskin became their self-appointed champion, writing a letter to the *Times* in their defense in 1851.

Edward Linley Sambourne (1844–1910)
An illustrator and satirist, Sambourne was a regular cartoonist for *Punch*. His style was notable for fanciful images and brief, witty captions. The Aesthetic Movement became one of his favorite targets, but his own home at 18 Stafford Terrace in London survives as one of the best-preserved aesthetic interiors.

Frederick Sandys (1829–1904)
Never a member of the Brotherhood, Sandys entered Rossetti's circle in the 1860s. His style reflected that of the more sensuous phase of Rossetti's development, featuring half-length portraits of alluring women, ornamented with rich textiles, jewels, and flowers and given evocative titles from legend and literature.

Elizabeth Siddal (1829–62)
Siddal began to model for the Pre-Raphaelite Brotherhood around 1851. She posed for Millais's *Ophelia*, lying for hours in a bathtub, but soon became Rossetti's exclusive model and muse, notably for his interpretations of Dante. An accomplished painter, but troubled with physical and emotional problems, she married Rossetti in 1860 and died of an overdose of laudanum in 1862.

Frederick George Stephens (1828–1907)
An original member of the Pre-Raphaelite Brotherhood, Stephens gave up his aspirations to become a painter early in his career to write art criticism. He became an eloquent

spokesman for the circle and its objectives and wrote regularly for the weekly journal the *Athenaeum* from 1860 to 1900.

Alfred Tennyson (1809–92)
Although published as a poet before he left Cambridge University in 1829, recognition came to Tennyson with his collection *Poems* (1842). Appointed Poet Laureate in 1851, the Pre-Raphaelite Brotherhood listed him among their "immortals." His *Idylls of the King* (1859–1885) retold the Arthurian legend for his generation.

Ellen Terry (1847–1928)
From her childhood through her old age, Terry led a theatrical career. She retired from the stage twice, first for a year during her brief marriage to George Frederick Watts and then for several years to live with the architect and stage designer Edward Godwin, with whom she had a daughter and a son, Gordon. She was renowned for her work with actor Henry Irving and her interpretation of Shakespeare.

John William Waterhouse (1849–1917)
A full generation younger than the original Pre-Raphaelite Brotherhood, Waterhouse's art reflects their powerful and enduring influence. His mature work combined their fidelity to nature with a fresh atmospheric quality inspired by French Impressionism, while his interpretation of subjects, both classical and medieval, suggests the ambiguity of Symbolism.

George Frederick Watts (1817–1904)
Never a member of the Pre-Raphaelite circle, Watts pursued a traditional career, competing as a history painter for the interior decoration project at the new palace at Westminster. Like the Pre-Raphaelites, he sought an art of genuine sentiment

and explained that his work, often ambiguous in its allegorical references, was based on ideas rather than things.

Oscar Wilde (1854–1900)
The Irish-born Wilde became a regular figure in London social circles after he completed his education at Oxford University in 1878. Noted for his wit and his wardrobe, Wilde became the most articulate spokesman for the Aesthetic Movement, and undertook a lecture tour of North America in 1882 to speak about interior decoration and the art of the Pre-Raphaelites.

Alexa Wilding
Tall and classically beautiful Wilding was a dressmaker when Rossetti first saw her on a summer evening in 1865. He persuaded her to model solely for him and paid her a weekly retainer. Wilding may be recognized in Rossetti's work through the early 1870s. Her dates are not known.

Franz Xaver Winterhalter (1805–73)
The German painter Winterhalter was renowned as a court portraitist throughout Europe. During the years 1842 to 1871, he painted more than one hundred commissions for the British monarchy, although he never resided for any extended length of time in England.

Mary Zambaco née *Cassavetti* (1843–1914)
A member of the Ionides family, the core of a affluent and sophisticated Greek enclave in London, Zambaco married a physician Dr. Demetrius Zambaco, famous for his research on venereal disease. She left him in 1866 and returned to London with her son and daughter. A talented sculptor, Zambaco modeled for Burne-Jones from 1868 to at least 1870, during which time they were romantically involved.

Selected Readings

The Pre-Raphaelites

Barringer, Tim. *Reading the Pre-Raphaelites*. New Haven and London: Yale University Press, 1998.

Casteras, Susan P. *Images of Victorian Womanhood in English Art*. London and Toronto: Associated University Presses, 1987.

Christian, John (ed.). *The Last Romantics: The Romantic Tradition in British Art Burne-Jones to Stanley Spencer*. London: Lund Humphries, 1989.

Gere, Charlotte with Lesley Hoskins. *The House Beautiful: Oscar Wilde and the Aesthetic Interior*. London: Lund Humphries, 2000.

Hares-Stryker, Carolyn (ed.). *An Anthology of Pre-Raphaelite Writings*. New York University Press, 1997.

John Ruskin and the Victorian Eye. New York: Harry N. Abrams, 1993.

Lambourne, Lionel. *The Aesthetic Movement*. London: Phaidon Press Ltd., 1996.

Lambourne, Lionel. *Victorian Painting*. London: Phaidon Press Ltd., 1999.

Marsh, Jan. *Pre-Raphaelite Sisterhood*. London: Quartet Books, 1985.

Marsh, Jan and Pamela Gerrish Nunn. *Pre-Raphaelite Women Artists*. Manchester City Art Galleries, 1997.

The Pre-Raphaelites. London: The Tate Gallery, 1984.

Prettejohn, Elizabeth. *The Art of the Pre-Raphaelites* Princeton University Press, 2000.

Warner, Malcolm. *The Victorians: British Painting 1873–1901*. New York: Harry N. Abrams, 1997.

Wildman, Stephen. *Visions of Love and Life: Pre-Raphaelite Art from the Birmingham Collection, England*. Alexandria, Virginia: Art Services International, 1995.

Wood, Christopher. *The Pre-Raphaelites*. New York: The Viking Press, 1981.

Wood, Christopher. *Victorian Painting*. Boston: Bulfinch Press, 1999.

Floral Culture

Goody, Jack. *The Culture of Flowers*. Cambridge, New York: Cambridge University Press, 1993.

Grigson, Geoffrey. *Dictionary of English Plant Names*. London: Allen Lane, 1974.

Heilmeyer, Marina. *The Language of Flowers: Symbols and Myths*. Munich, Berlin, London, New York: Prestel, 2001.

Hyam, Roger and Richard Pankhurst. *Plants and Their Names: A Concise Dictionary*. New York: Oxford University Press, 1995.

Seaton, Beverly. *The Language of Flowers: A History*. Charlottesville and London: University Press of Virginia, 1995.

Ward, Bobby J. Ward. *A Contemplation Upon the Flowers: Garden Plants in Myth and Literature*. Portland, Oregon: Timber Press, 1999.

Nineteenth-century Flower Books

Burne-Jones, Edward. *The Flower Book*. London: Reproduced by H. Piazza *et cie* for The Fine Arts Society, 1905.

Friend, Hilderic. *Flowers and Flower Lore*. London: W. Swan Sonnenschein and Company, 1884.

Greenaway, Kate. *Language of Flowers*. London: Warne, 1884.

Ingram, John Henry. *Flora Symbolica; or, the Language and Sentiment of Flowers*. London: Frederick Warne and Company, 1869.

Latour, Charlotte. *Le Langage des fleurs*. Paris: Audot, 1819.

Loudon, Mrs. John Claudius. *The Ladies' Flower-Garden of Ornamental Annuals*. London: William S. Orr and Company, 1849.

Philips, Henry. *Floral Emblems*. London: Saunders & Otley, 1825.

Shoberl, Frederic. *The Language of Flowers; With Illustrative Poetry*. London: Saunders & Otley, 1834.

Tyas, Robert. *The Sentiment of Flowers; or, Language of Flora*. London: Tilt, 1836.